IMAGES OF ENGLAND

# Sedgefield &
# Bishop Middleham

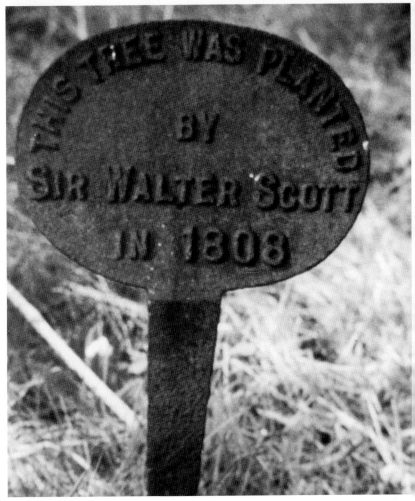

Robert Surtees, the County Historian, became a great friend of Sir Walter Scott, the writer, and exchanged many letters, nearly all containing notes of an historical nature. Although they remained firm friends until Robert died in 1834, Scott only visited Surtees' home in Mainsforth on one occasion when he planted a young oak tree in the Hall grounds. Unfortunately the tree no longer remains but there is a cast iron plaque to commemorate the occasion with Scott's name and the date 1808. A countryman himself, Sir Walter was known for his love of trees and in particular the native oak tree which was his favourite. During the autumn he seldom went out without a few acorns in his pocket which were planted in both the hedgerow and by the wayside.

IMAGES OF ENGLAND

# Sedgefield &
# Bishop Middleham

Frank Bellwood
& Sedgefield Local Historical Society

NONSUCH

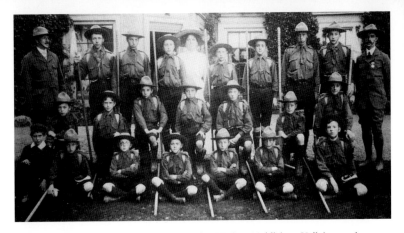

Bishop Middleham Scout Troop in the grounds of Bishop Middleham Hall, home of Matthew Forster, the Brewery owner, c. 1910. Because of his association with Lord Baden-Powell in the Boer War, General Sir Herbert Conyers Surtees of Mainsforth Hall, took an interest in the Scout movement. Consequently Middleham was in the fore-front of having a scout troop in 1910, only two years after the movement was founded in 1908. The General became its first County Commissioner.

First published 1997
This new pocket edition 2006
Images unchanged from first edition

Nonsuch Publishing Limited
The Mill, Brimscombe Port,
Stroud, Gloucestershire, GL5 2QG
www.nonsuch-publishing.com

Nonsuch Publishing is an imprint of Tempus Publishing Group

British Library Cataloguing in Publication Data.
A catalogue record for this book is available from the British Library.

ISBN 1-84588-178-8

Typesetting and origination by Nonsuch Publishing Limited
Printed in Great Britain by Oaklands Book Services Limited

# Contents

# Foreword

The production of this book was as inevitable as it is timely. Inevitable because it is about an area which has much to offer as a beautiful place to live and raise a family; and timely because this same area is also an increasingly receptive environment for trade and commerce. Through the years Sedgefield has been a focal point for surrounding communities, including Bishop Middleham, Mainsforth and Winterton, and as such laid down a unique history – a rich tapestry of South East Durham.

County Councillor
Kenneth Manton

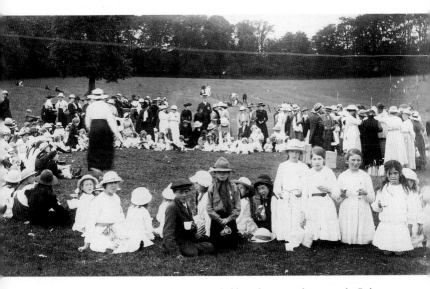

Peace celebration, July 1919. The celebration was held in what is now known as the Robert Brown Showfield, one year after the end of the First World War. Notice the Boy Scout in the centre, resplendent in his uniform.

# Introduction

## Sedgefield

Although it has its origins in the tenth century when it was known as 'Ceddesfield', it is believed that there was a settlement here in Roman times. Maps of Roman roads show a route passing through Sedgefield and rumour has it that the remains of a Roman villa were discovered during the building of a new housing estate in the sixties but unfortunately quickly built over. The name 'Ceddesfeld' has been immortalised in the title of the Community Association building, Ceddesfeld Hall, the former Rectory. Some believe that this name refers to a person called 'Cedd' or 'Secg', a Saxon warrior who was possibly granted the land; others believe the name refers to 'field of the sedge', which would fit in well with the marshy nature of the area. By the twelfth or thirteenth centuries, the settlement had become known as 'Seggefield' or 'Segesfeld'.

The community, situated on a low gravel hill rising to no more than four hundred feet above sea level, owed its growth to its excellent situation in the midst of prime agricultural land. The scenery around has always been noted for its pleasantness and tranquillity and, in fact, in past centuries a stay in Sedgefield was often recommended for those suffering from an illness. Its growing prosperity was due to its function as a market town for the surrounding area and in fact the agricultural market continued until just a few years ago. The original site of the market was marked until the early years of the nineteenth century by a large cross standing on 'Cross Hill', the area next to the Parish Church. Although the cross itself has long gone the name of the hill continues as a reminder. In 1823, the eminent local historian Surtees describes Sedgefield as 'A small, neat, market town, with the appearance rather of a handsome village ... considerably elevated above the marshy lands to the south and west ... ' Many of the buildings date from the seventeenth century although the remains of mediaeval buildings may well exist beneath their foundations. Many of these buildings have been tastefully restored and provide much interest in the conservation area in the centre of the village. In earlier years many of the roofs were thatched.

Hardwick Hall lies close to Sedgefield and is a much visited country park. A house with extensive grounds existed here in 1449 but the present house, in the 1750s, was lived in by John Burden, a local gentleman who spent much money on grounds that contained several follies, to the design of James Payne, as well as a series of artificial lakes. James Payne's original designs for the house were never realised since John Burden ran out of money. By the middle of the nineteenth century Viscount Boyne and his family were occupying the Hall but the rot began to set in during the depression years of the 1920s when the grounds became neglected and the buildings fell into disrepair. During the last war, the Hall became a centre for the 'Bevin Boys' and then a Maternity Hospital before finally becoming the hotel that it is today.

The population of Sedgefield expanded rapidly in the 1860s with the opening of the County Lunatic Asylum about a mile to the north in 1858. This enormous establishment later became known as Winterton Psychiatric Hospital and closed completely in 1997.

In recent years there has inevitably been much new building in Sedgefield with a corresponding increase in population. However the centre of the town, having been designated a conservation area, retains much of its old charm and is fairly resistant to modern change.

# Bishop Middleham

Bishop Middleham is an attractive village, surrounded by stately beech and sycamore, the beautiful thirteenth-century parish church dedicated to St Michael its crowning glory. Documents show that a church had existed as early as 1146 when Ranulfus, son of Ranulf Flambard, Bishop of Durham from 1099-1128 was appointed the first Rector. The church stands a stone shot from the ruins of a fortified Manor House, both of which are situated upon the same bluff of land, that gently rises above the lush water meadows of the River Skerne.

In 1072 William the Conqueror built the castle at Durham on the narrow neck of land separating the River Wear which commanded an excellent view, and approach to the city. Further castles were built at Stockton beside the River Tees, and also at Darlington, close by the River Skerne. Being situated in an almost central position to all three castles, Middleham became a favourite seat of the early Bishops, in other words, their middle home. There are several documents that point to a fortified Manor House or Castle existing here as early as 1099, and it is because of the Bishop's decision to build at Middleham that the village owes its very existence to the Church.

Thought to have derived from Anglo Saxon origins, Middleham was, as its place name suggests, the middle ham, meaning middle homestead or settlement. However, it is a far cry from this nuclear age to the year 1146 when the name of 'Midelham' spelt by monkish scribes appears on the Grant of Osbert the Sheriff who gave the church of St Michael's to the Monastery at Durham. Later John Speed who drew the Bishopric Map in 1611 marks it as Midlam, and although it has come down through the centuries and spelt many different ways it is not until 1613 we find the prefix of Bushopp Middlehame taken from the parish register which commenced in 1559.

Middleham is almost central to the neighbouring villages of Cornforth and Sedgefield, along with Mainsforth and the disappeared medieval village of Holdforth. At least two of these villages are known to pre-date the Norman Conquest. During Bishop Hatfield's period of office from 1345-81 documents became less frequent and by 1384 the Manor House is reported to be worth nothing beyond reprises. After that date all reference to the Bishops' occupation ceased. Neglected and ravaged by the hand of time, James Pilkington, the first Protestant Bishop of Durham, from 1561-76, gave the villagers permission to build their cottages with stone from the Castle. In 1649 what was left of the Castle along with the land, was sold by the Trustees for Church Lands. However it is interesting to find that a square tower remained standing until 1790, possibly at the south west corner. Although finally deserted as an ecclesiastical residence, the agricultural settlement which grew up around the Manor and church continued to exist. The population could not have been very large for in 1801 there were only 331 inhabitants in the village. Twenty years later there were 387 inhabitants and 82 dwellings, and by the middle of the nineteenth century the old village had more or less taken on its shape that was to last for a further century. A few of these old cottages still survive today but many were demolished during the middle of the 1950s and early '60s and replaced with council houses.

During the past forty years, evidence has revealed the presence of Bronze Age Man. During the summer of 1953, village schoolboys Arnold Atkinson and Derek Johnson found a flint arrow head, identified as belonging to the Early Bronze Age, 1800-1000 BC. While in May 1966 Arthur Bellwood, the gardener at Bishop Middleham Hall, dug up within the shadow of St Michael's church, a blue glass bead, whose edge is surrounded with five white spirals. Dr D.W. Harding, Lecturer in Celtic Archaeology at Durham University, confirmed that the bead was Iron Age and dated as being 2,500 years old from what is described as the La Tene period, approximately 500 years BC. La-Tene along with the Hallstatt culture, refer to towns in both Switzerland and Austria, where between 700-500 BC the first artefacts of iron began to replace bronze. With the discovery of these important artefacts it would suggest there has been a continuity of people living at Bishop Middleham for a period of at least 3000 years and although we shall never know it may well be those far off settlers of so long ago were the first people to utter the name of Midlam.

# One

# Around Sedgefield

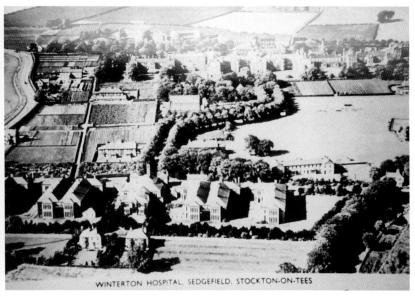

WINTERTON HOSPITAL, SEDGEFIELD, STOCKTON-ON-TEES

An aerial view of Winterton Hospital from the south with Neville Wards in the foreground. Winterton Hospital was once reputed to be the largest psychiatric hospital in Britain and was the major employer in the villages around Sedgefield.

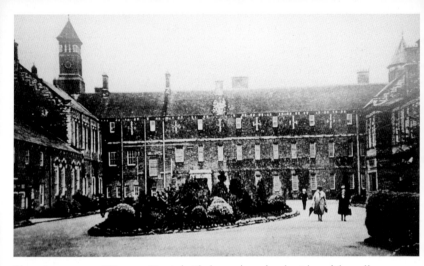

The main entrance to Winterton Hospital with the men's ward to the right and the staff canteen, now known as the Chimes Restaurant, to the left. Originally known as the Durham County Lunatic Asylum, it was opened in April 1858, with the admittance of eleven inmates from Bath Lane Licensed House, Newcastle, followed shortly afterwards by several inmates from Durham prison. The search for land suitable for an asylum was started in 1854 by the County Justices after a Royal Commission, sponsored by Lord Shaftesbury, identified the need for such a hospital in response to the Paupers and Lunatics Acts of 1808 and 1853. In 1855 the Justices negotiated to buy 52 acres of farmland lying between Sedgefield and Fishburn for £4,000. The County Architect and Surveyor, Mr John Howison, was then appointed to draw up the plans, and building work commenced in 1856. The cost of the bricks was £24 per thousand and all of them were made by steam. They were laid in Flemish Bond, without cavity walls and three bricks thick, with 3/16ths mortar and tuck pointed. The buildings were roofed with Langdale slates with copper nails and built on the lines of Fox and Barratt's fire proof principles. The first stage of building was completed by October 1857, with the main building, chapel and offices. Workshops had also been completed. It was intended from the start that the hospital would be self-supporting and over the next two or three years more land was bought, eventually amounting to about 350 acres and included three farms in 1879. In 1884 St Luke's church was consecrated for the use of patients and staff and contains a fine organ. A gas works was built to the north east of the main hospital, and water was obtained from the hospital's own well and later, in 1878, from Maggie's Well about half a mile away to the north west. This continued until 1895 when an agreement was made with Weardale and Shildon Water Works for the supply of water. As more and more patients were referred to the hospital, serious overcrowding took place so that by 1879 there was a total of 1,106, necessitating the transfer of some inmates to other hospitals and the continual building of new wards. Inmates worked in the gardens or farms. Workrooms for making clothing, etc., together with a cobblers shop for the making and repairing of footwear were established from the start. Rooms were heated by 'open ovens', later by hot air and in 1877 steam machines were installed in the laundry. A Fire Brigade was formed in 1881 and manned by members of staff. Over succeeding years the hospital continued to expand (in 1930 there were 1,599 patients), and in 1948 came under the management of the National Health Service. The name was changed to Winterton sometime between the two wars.

# DIETARY SCALE.

| DAYS. | BREAKFAST. MALES. | BREAKFAST. FEMALES. | DINNER. MALES. | DINNER. FEMALES. | SUPPER. MALES. | SUPPER. FEMALES. |
|---|---|---|---|---|---|---|
| Sunday | 1 pint Tea<br>8 oz. Bread<br>¾ do. Butter<br>¼ do. Sugar | 1 pint Tea<br>7 oz. Bread<br>¾ do. Butter<br>¼ do. Sugar | Roast beef (cooked<br>free from bone) ...6 oz.<br>Potatoes or other<br>  Vegetables ... 10 do.<br>Bread ... ...4 do.<br>Rice Pudding... ...8 do. | Roast Beef (cooked<br>free from bone) ...4 oz.<br>Potatoes or other<br>  Vegetables ... ...6 do.<br>Bread ... ...3 do.<br>Rice Pudding... ...6 do. | 1 pint Tea<br>8 oz. Bread<br>¾ do. Butter<br>¼ do. Sugar | 1 pint Tea<br>6 oz. Bread<br>¾ do. Butter<br>¼ do. Sugar |
| Monday ...... | ditto | ditto | Australian Mutton 6 oz.<br>Potatoes ... ...8 do.<br>Bread ... ... 4 do. | Australian Mutton 6 oz.<br>Potatoes ... ...6 do.<br>Bread ... ...3 do. | ditto | ditto |
| Tuesday ...... | ditto | ditto | Pea Soup ... 1½ pints<br>Potatoes ... ... 8 oz.<br>Bread ... ... 7 do. | Pea Soup ... 1½ pints<br>Potatoes ... 6 oz.<br>Bread ... ... 6 do. | ditto | ditto |
| Wednesday.. | ditto | ditto | Baked Pie (beef) 10 oz.<br>Potatoes ... ... 8 do.<br>Bread... ... 4 do. | Baked Pie (beef) 8 oz.<br>Potatoes ... 6 do.<br>Bread ... 3 do. | ditto | ditto |
| Thursday .... | ditto | ditto | Suet Pudding... 16 oz. | Suet Pudding... 13 oz. | ditto | ditto |
| Friday......... | ditto | ditto | Soup ... ... 1½ pints<br>Potatoes ... ... 8 do. | Soup ... ... 1½ pints<br>Potatoes ... 6 oz. | ditto | ditto |
| Saturday .... | ditto | ditto | Sea Pie ... ... 10 oz.<br>Potatoes ... .. 7 do.<br>Bread ... ... 4 do. | Sea Pie ... ... 8 oz.<br>Potatoes ... ... 6 do.<br>Bread ... ... 3 do. | ditto | ditto |

A typical diet sheet for the patients of Winterton Hospital. Notice the smaller quantities for the female patients. Food came from the farms and gardens with bread being baked on the premises. In 1860 it cost 9s 1d per week for each inmate, and the hospital had a very liberal allowance of beer. Tobacco and snuff were also available for those who wanted them.

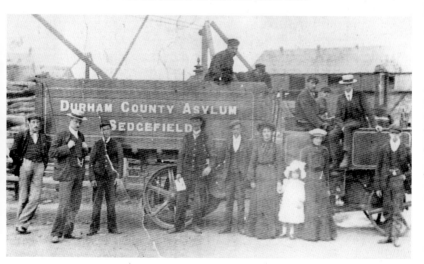

The steam wagon, belonging to Durham County Lunatic Asylum (Winterton Hospital) carrying timber at Thubron's timber yard near Sedgefield Station.

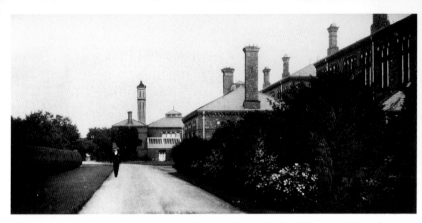

The entrance to Durham County Lunatic Asylum now known locally as Winterton Hospital. Winterton is now in the process of being run down in response to the Government's 'Care in the Community' policy.

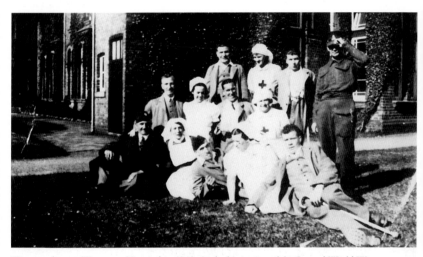

War casualties at Winterton Hospital in 1940. At the beginning of the Second World War some wards were cleared ready for civilian casualties. The hospital now known as Sedgefield Community Hospital was established as an Emergency Hospital in 1940. It was originally two rows of large huts with the open space between them later roofed over to form a wide central corridor. It later became Sedgefield Community Hospital and it took patients from the surrounding area for a wide variety of treatments and surgery. When North Tees Hospital was opened the General Hospital was downgraded to a Community Hospital and the number of wards reduced. When a replacement for it is built it will be closed.

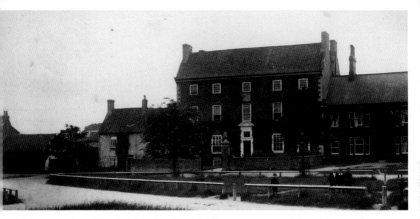

The Manor House. This Grade II listed building is a fine example of Queen Anne architecture. Built in 1707, the building has been put to a variety of uses. In earlier years it served as a home for the local Curate, and was at one time a school for young boys. In more recent years it was the main offices of Sedgefield Rural District Council together with a jail and a Local Magistrates Court. The building contains several important features including a large arched window at the rear, a dog gate and a black oak staircase with barley sugar spindles.

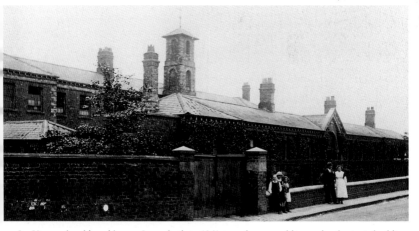

Ivy House, the old workhouse. It was built in 1861 to replace a rambling and unhygienic building where East Well Close now lies. As a purpose built workhouse it contained the latest ideas for pauper welfare and was way ahead of its time. In its last few years it provided a home for the elderly and finally a base for the village youth club. It achieved brief fame as a location for one of the early televised 'Catherine Cookson' films. It closed as an old people's home around 1975 and was demolished in the early 1990s

Hardwick Hall. A view of the south east elevation of Hardwick Hall showing the rather badly maintained exterior in the early 1900s.

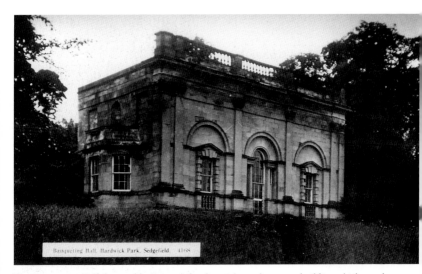

Banqueting Hall, Hardwick Park, Sedgefield.   4168

The Banqueting Hall designed by Paine. A fine late eighteenth-century building which stood on a lawn sweeping down to the edge of the serpentine canal.

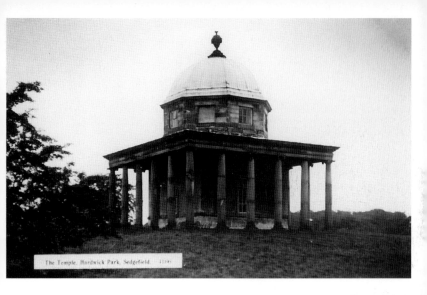

The Temple, Hardwick Park, Sedgefield. 1104

*Above:* The Temple of Minerva, one of the follies originally built on the Hardwick estate by John Burdon. The domed octagonal temple, with its adjacent colonnade, boasted a beautiful painted interior which is now reduced to a ruin.

*Right:* The Folly at Hardwick Hall with Neptune in the foreground. The statue mysteriously disappeared during the war but a similar figure can be seen in Durham Market Square.

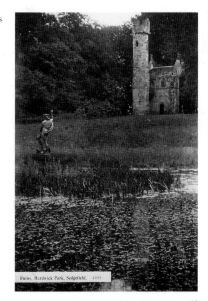

Ruins, Hardwick Park, Sedgefield. 1105

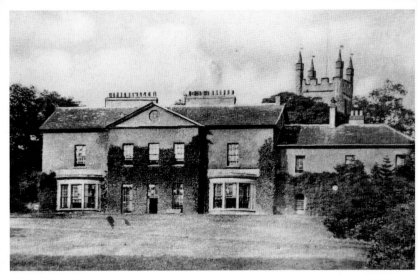

The ivy covered southern elevation of the Sedgefield Rectory. This view looks down onto a terraced lawn which leads to a picturesque lake – a beautiful natural setting. It is now known as Ceddesfeld Hall and is currently the home of the very active Sedgefield Community Association. The Rectory has a number of interesting stories associated with it including the 'Pickled Parson' story.

'About two o'clock in the morning, a fire broke out in one of the lodging-rooms in the rectory-house at Sedgefield, in the county of Durham, which consumed the greatest part of the building before it was extinguished; by the activity of the people of the neighbourhood the most valuable part of the furniture was preserved. The superstitious and vulgar inhabitants of Sedgefield were, previous to the burning down of the rector-house, alarmed by an apparition, denominated the Pickled Parson, which for many years was presumed to infest the neighbourhood of the rector's hall, 'making night hideous'. The supposed origin of the tale is attributed to the cunning of a rector's wife, whose husband having died about a week before the tithes (which are generally let off to farmers and the rents paid on the 20th December) became due, she concealed his death by salting his body in a private room. Her scheme succeeded; she received the emoluments of the living, and the next day made the decease of the rector public. Since the fire the apparition has not been seen.' *31 December 1792, from Local Records Volume I by John Sykes, 1866*

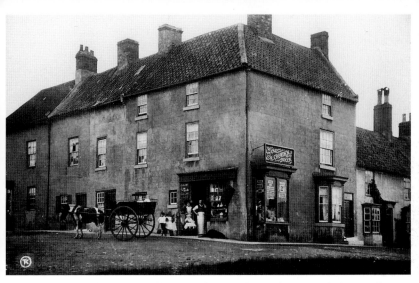

A view of 'Crosshill' showing an old fashioned grocery shop on the corner. The horse and cart are in the process of delivering milk. This building today forms the 'Crosshill' Hotel.

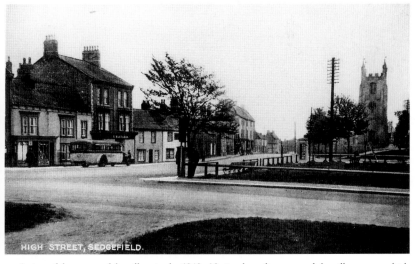

A view of the centre of the village in the 1940s. Notice the railings around the village green which have now gone.

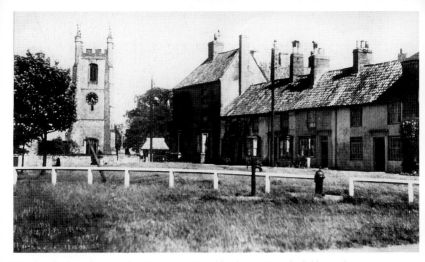

The church, from the west, showing some of the oldest houses in Sedgefield, now known as The Square.

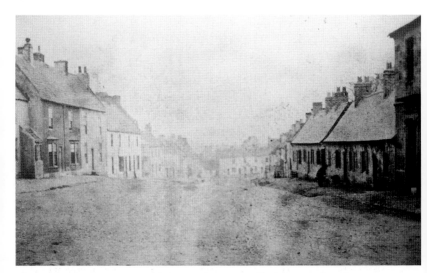

The view down Front Street, c. 1895, showing the Coopers Almshouses on the right.

Sedgefield Mechanics Institute now the modernised Parish Hall. It was founded in 1849 as an institute of 'Literature and Science' and was initially a flourishing institution with a sizeable free library and good reading and recreation rooms. Early in the twentieth century concerts were given every Saturday night by talented local people. Today the Parish Hall is well used by many local organisations and is the base for the Sedgefield Town Council.

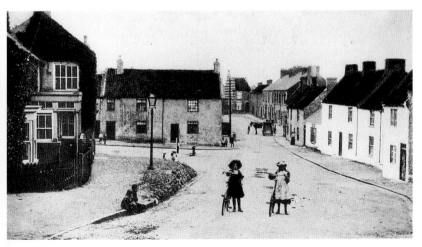

A view from the west looking down Rectory Row with Cross Street on the left. Notice the two young ladies with their equivalent of today's 'Mountain Bikes' and their two small admirers in the gutter.

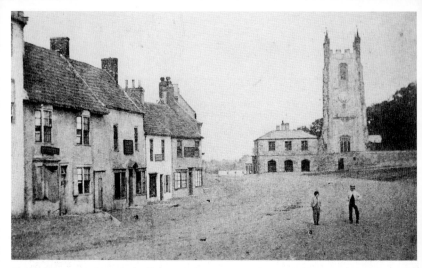

The High Street, c. 1896. The building to the left of the church was the school house with the jail on the ground floor. This school was built in 1826 on the site of an early eighteenth-century school house and at the time of this photograph educated between forty and fifty boys and girls, with two boys learning Latin.

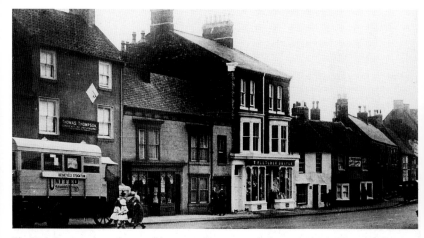

The High Street in the early part of the twentieth century with the service bus waiting to pick up passengers for Stockton. Fletchers the Drapers, the three storied building with the white bay windows, was a noted early 'department' store which sold a wide variety of goods and flourished for many years.

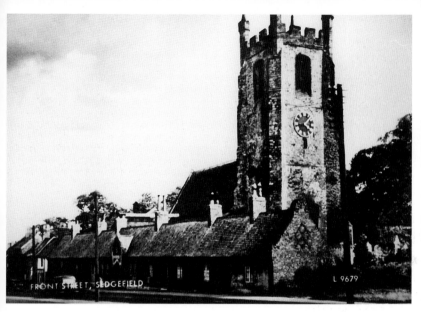

A view of the church showing the 'Coopers Almshouses' built in 1702 on the order of Thomas Cooper, surgeon of Sedgefield. He set aside a sum of £100 for the erection of ten Almshouses for five poor men and five poor women. The beneficiaries had to wear a blue coat with the letters T.C. in yellow on the sleeves. The administrators of the charity were apparently unwilling to spend money on the upkeep of the almshouses in the nineteenth century when it became difficult to find people to live in them. There were even cases of people leaving the almshouses to live in the workhouse out of preference. The almshouses survived until the late 1960s by which time they had fallen into disrepair and were unfortunately demolished.

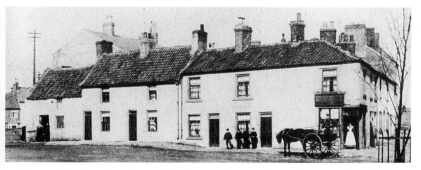

A view of The Square from the west. The horse and cart stands outside a corner shop which fulfils that purpose to the present day.

The West End looking towards the village. The Nag's Head public house is in the centre of the picture. The tall building on the extreme right is Sedgefield House, on the corner of Spring Lane. It is a Regency House, thought to have been the vet's house in the nineteenth century.

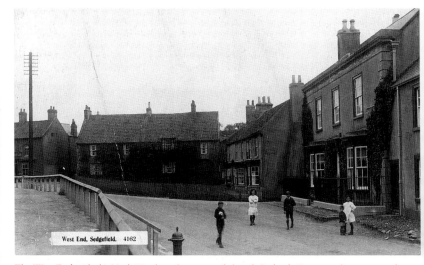

West End, Sedgefield. 4162

The West End with the Nag's Head on the extreme left with Badger's Green, in the centre, and Sedgefield House on the right.

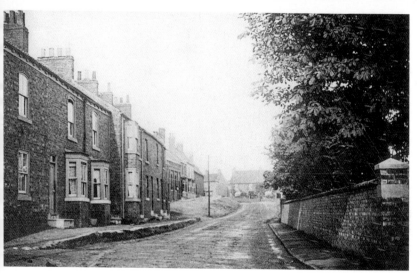

The West End looking towards the village from the start of Station Road. Again Badger's Green and the Nag's Head are in the distance.

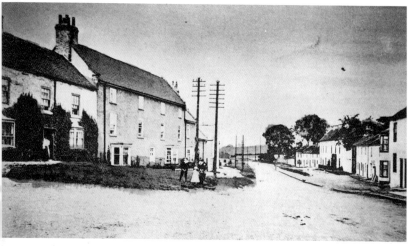

North End in the early 1900s. Many of the frontages remain little altered to the present day. Electric street lighting did not arrive in Sedgefield until after the First World War but the electricity poles in this photograph indicating its earlier arrival for other purposes.

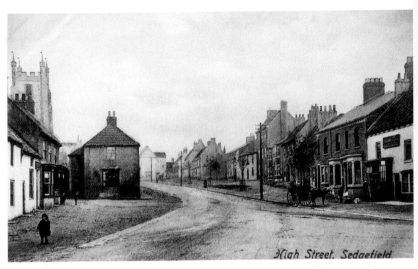

The High Street looking up the hill towards the centre of the village. The public house on the right is the Dun Cow.

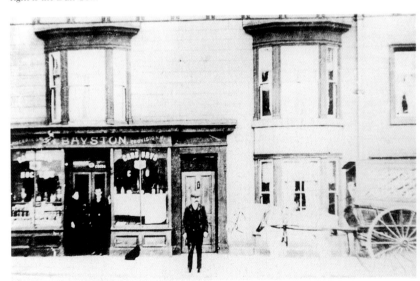

Bayston's shop at the West End of the High Street. It is a shop to this day, now named 'Selections' selling cards and gifts.

Sedgefield church from the south east looking across farmland, with the wall surrounding the Rectory garden in the middle ground.

Rectory Row, showing the corner of the Rectory wall next to the Tenements.

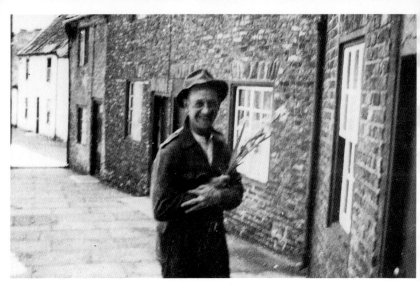

A view of the Tenements further along Rectory Row, previously known as Paradise Row. The gentleman in the picture is Edwin 'Ted' Threlfell, a well-known figure around the village.

Looking across at the church from the stack yard behind the Tenements, Rectory Row.

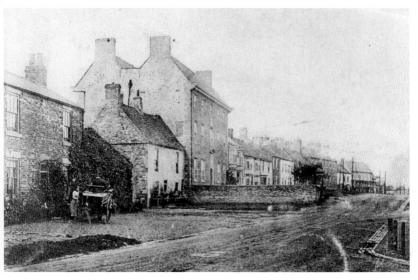

The Manor House and West End looking north, at the beginning of the twentieth century. Town Farm is on the far left. Notice lack of pavements and railings around the grounds.

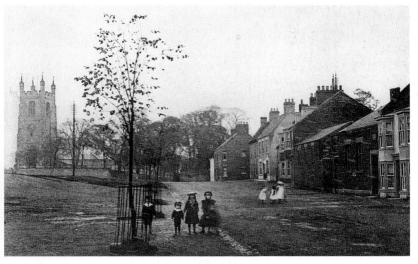

A view of the church and Rectory Row at the beginning of the twentieth century. Despite the newly planted trees, this view is little different today.

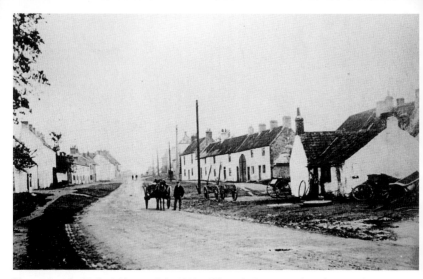

The north end of Sedgefield around the 1920s. Alderson's Garage, on the right, is on the present site of West Park Motors. The lack of motor vehicles makes this scene quite idyllic compared with this busy road today.

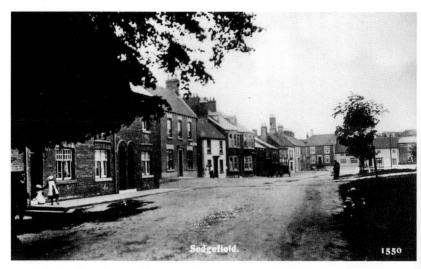

Rectory Row in the early part of the twentieth century. Many of these houses have altered little over the years. The village stock yard lay close to the vehicle in the distance.

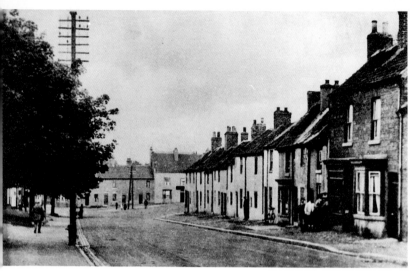

Front Street, with the road swinging round to the right in front of the Golden Lion public house.

The corner of Cross Street and Rectory Row. The building behind the young lady is now converted into a Social Club.

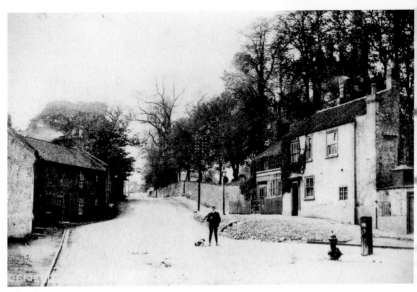

A view of Rectory Row to the west. Notice the old village pump in the road in front of the 'future' Social Club.

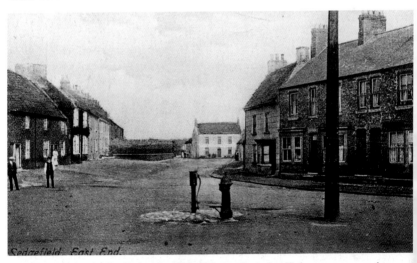

The village pump at the East End of the village. Once mechanical traffic became common, this pump became a constant hazard and its damage often caused flooding.

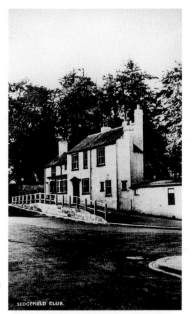

SEDGEFIELD CLUB.

*Right:* The newly converted Sedgefield Social Club on Rectory Row, for male members only.

*Below:* A view of the 'smokey' East End of the village with Orchard Farm on the right and the mandatory horse and cart moving towards the village centre.

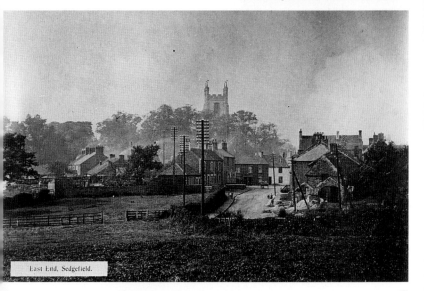

East End, Sedgefield.

Ceddesfield Hall home of the present Community Association since 1973 was originally the Rectory, built in 1792 after the previous Rectory was burned to the ground. The incumbent at the time, Revd George (subsequently Lord Viscount) Barrington had the good fortune to be the nephew of two distinguished gentlemen, the Hon. Admiral Sir Samuel Barrington and Bishop Shute Barrington, Lord Bishop of Durham. These two decided that their nephew should live 'in the manner to which he was accustomed' and the result was a miniature 'stately home' of considerable size with a large walled garden.

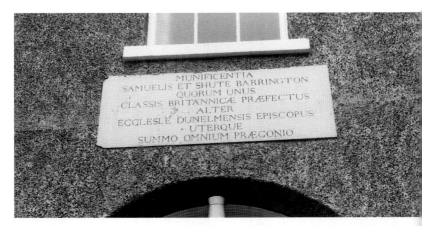

The plaque above the front door of Ceddesfield Hall commemorating its building in 1792 and the generosity of the benefactors Sir Samuel Barrington and Bishop Shute Barrington. It reads: 'By the bounty of Samuel and Shute Barrington of whom one was Admiral of the Fleet the other was Bishop of the Church of Durham both of the highest renown.'

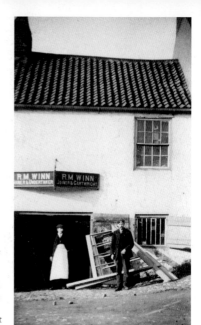

*Right:* R.M. Winn 'Joiner and Undertaker', *c.* 1920. This house lies in the centre of the village and is now known as 12, The Square.

*Below:* Looking up Front Street from the East End showing one of the village pumps. The old houses in the shadow of the church were pulled down in the late 1960s. The two houses on the extreme left are still standing.

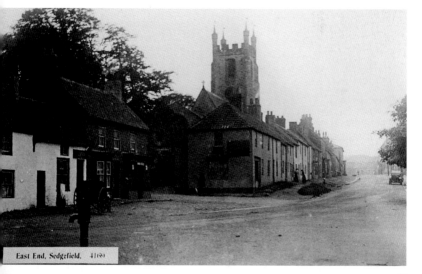

East End, Sedgefield. 41169.

Hardwick Arms, the old coaching house hotel. During previous centuries, Sedgefield was an important coaching centre and the village stood on the main turnpike road between Stockton and Durham. A turnpike gate, the earliest in the county, stood at the Stockton entrance to the village and was still there in 1857. Coaches set passengers down and picked new ones up at the Hardwick Arms. Notice the archway through the centre of the hotel which gives access to a cobbled yard at the rear for the coach and horses. The local policeman in the middle of the road is directing the 'Traffic Jam'.

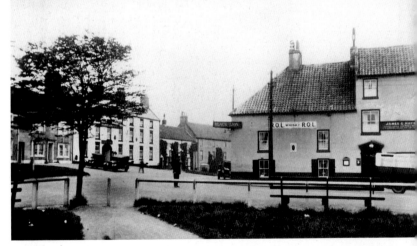

The Black Lion, on the corner of the High Street, c. 1930. The policeman is still standing in the middle of the road. This photograph shows how close the Black Lion is to the Hardwick Arms and how very little this corner has changed to this day.

## Two

# Around Bishop Middleham and Mainsforth

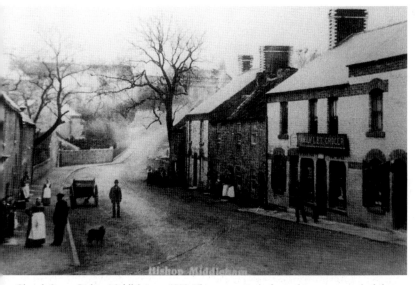

Church Street, Bishop Middleham, c. 1893. The woman in the long white apron, on the left, is Mrs Graham, landlady of the Dun Cow Inn. She took over the inn with her husband, Joseph, in the early 1870s. After thirty years they were succeeded by William Legg in 1902. In the background is Church Bank, leading towards the Old Hall and St Michael's church. Centre right, Robinson Westgarth Crowther, the village blacksmith and his assistant stand under the spreading ash tree. The shop belonged to George Lee, the village grocer, patent medicine vendor and postmaster.

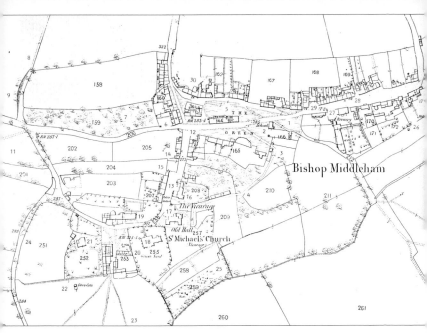

Bishop Middleham

Ordnance Survey Map of Bishop Middleham, 1856. Key: 1. Stock Hill where the village stocks stood from 1351-1818, also the site of the medieval Pinfold where stray animals were impounded. 2. First Church of England School built in 1770 erected from public subscriptions. 3. Park Gate Cottages, the north east entrance to the Old Hall. 4. Carriage Way that swept around The Park to the Old Hall. 5. Upper Front Street, Cock Pit Row, from the days when cockfighting was a legal sport. 6. The Old Manor House where the Halmote Court sat once every six months. 7. Nutgarth Wood provided edible nuts for the Lord of the Manor's table. 8. Stob Cross Lane led to Cornforth, once a hamlet in Middleham Parish. 9. Mary Lane, once a classic example of a sunken medieval way. 10. Mainsforth Lane leading to the ancient hamlet of Maynesford. 11. Evidence of the medieval ridge and furrow ploughing below Broad Oak Farm. 12. Dun Cow Inn, Church Street. 13. The village pump stood opposite the Old Vicarage. 14. Site of the village blacksmith shop. 15. The Forester's Tavern, Church Street. 16. The Old Vicarage. 17. The Old Hall. 18. St Michael's church, early thirteenth-century grave slabs in the porch. 19. Hall Farm, site of the Manorial Farm. 20. Hall Farm Cottages, possible site of Vicar William de Meneres house. 21. Castle View, site of a mansion house called Le Front in Le Falde which was owned by Sir George Freville in 1597. 22. Dove Cote Garth, a medieval dovecote stood until 1860. 23. Site of the Bishop's Castle. Records show a Manor existed as early as 1099. 24. Foumarts Lane. The name comes from the foulmartins, a species of polecat that lived in the old park wall, mentioned in 1349. Its boundary contained almost 98 acres of the Deer Park belonging to the Prince Bishops of Durham. 25. Site of the ancient Chestnuts Wood. 26. Drakers Lane. The name comes from Drago de Middleham, who held land here in the fourteenth century. 27. The Brewery. A brewery has existed in the village from at least 1700. 28. The Cross Keys. It once had its own blacksmith shop at the rear of its premises. 29. The Fleece Hotel, along with the Three Tuns, a former public house. 30. The Red Lion, converted into four private houses.

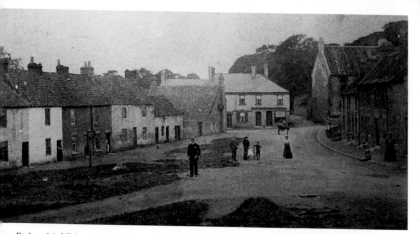

Bishop Middleham Village Green, 1896. The village pond was situated in front of the notice board to the left, while behind stood Lower Front Street, and the Dun Cow public house. Opposite stood Upper Front Street, formerly known as 'Cock Pit Row', and beyond, the Old Manor House and Church Street. A gate once straddled the road here to keep out vagabonds and other unwelcome characters. It is reputed that some of the sturdy old men, who whiled away their time on a nearby seat, would think nothing of taking a stick to them.

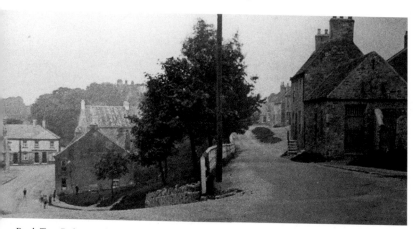

Bank Top, Bishop Middleham, c. 1918. The building, front left, which shows its gable end became the Church Institute. It was opened on Saturday, 6 November 1887 by the Bishop of Durham, the Right Revd Brooke Foss Westcott. A favourite with Durham miners, he became known as the pitman's Bishop and it was mainly through his efforts that the first Miners' Gala Service was held in Durham Cathedral in July 1897. After demolition, public lavatories were erected on the site in 1960. These were demolished in 1993.

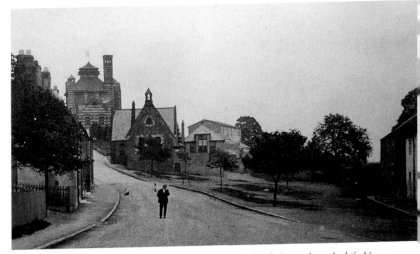

The Village Green, c. 1918. This view, from the Mainsforth Road, shows, from the left: Upper Front Street, followed by the Brewery, the Old School, Harry Manns joinery shop and Lower Front Street. The Park Gates and Cottages stood near the tree to the far right of the photograph. Edward Nobbs is the man standing on the road. He lived in No. 4 Upper Front Street.

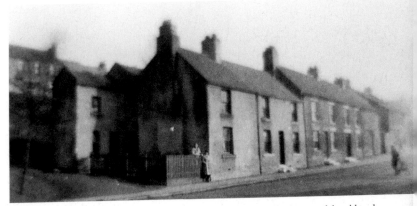

For almost half a century the Church Institute, which was built near the site of the old cock pit at the east end of Upper Front Street, was the hub of village activities and social life. Many senior residents still have fond memories of holding their wedding receptions at the Institute. The building housed a canteen during the Second World War for the soldiers who were guarding Germans and Italians imprisoned at the Brewery. The girls standing by the garden gate, in this 1914 photograph, are sisters Evelyn and Mary Nobbs.

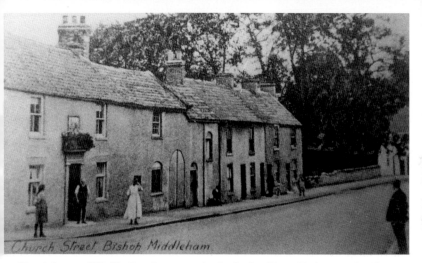

Church Street, *c.* 1924. The Dun Cow is considered to be the oldest public house in the village having its origins in the sixteenth century. The man standing at the doorway is the landlord Joseph Barker Ross. The boy, in the centre of the photograph, is sitting upon the old mounting stone, thought to have come from the Castle. It was used by horsemen who frequented the inn. The two houses, to the right of the boy, were demolished and replaced with council houses in 1960.

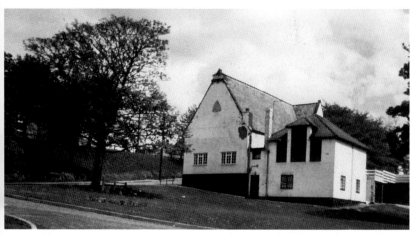

The Old School, 1972. Stripped of its 'Bell Tower', the school was converted to make two private dwellings. After a slightly different change to its outward appearance, it was painted black and white. During the early 1960s the 'showmen' came and erected their machines on this part of the village green. For many years men enjoyed playing quoits during the summer evenings.

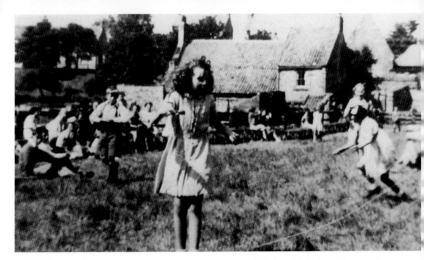

Ada Willis wins the egg and spoon race at the sports day held behind Park Gate Cottages in the 1940s. Built during the latter part of the seventeenth century, these cottages stood guard over the Carriage and Pedestrian Gates that gave access to the carriageway that swept through The Park to Bishop Middleham Hall, then owned by George Spearman. The cottages were demolished in the early 1950s.

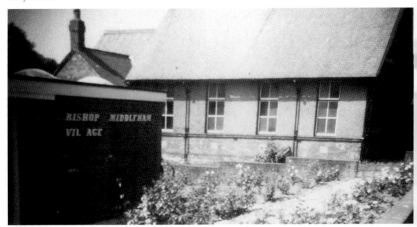

Bishop Middleham Wesleyan Methodist Chapel, 1970. Edwin Tranmer and his wife Louise of Hall Farm performed the opening ceremony at the new Wesleyan Chapel on 20 September 1913. Situated at the east end of Lower Front Street, it was built from red brick and partly pebble dashed with a blue slate roof. It was demolished in 1983 and two semi-detached houses were built on the site.

A view looking westwards from Stock Hill, c. 1950. Beyond is Church Street where the first street lamp, supported by a wrought iron bracket and operated by oil, was erected in 1902 by Revd Matthew Burra Parker. Electricity did not come to the village until the autumn of 1929.

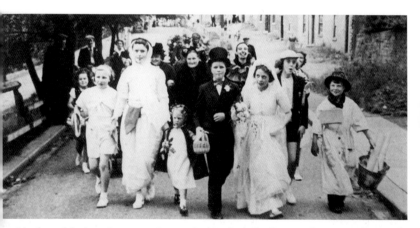

Members of the fancy dress procession parade along Bank Top Street on their way to the annual Field Day events held at Foumarts Lane in the summer of 1950. Shortly after this photograph was taken, the street was demolished and council houses were erected in 1955. Built upon a magnesium ridge with a south facing aspect, almost every cottage along Bank Top once had its own sundial secured above the doorway, several with early seventeenth-century dates carved upon them. A number survived until the beginning of the twentieth century.

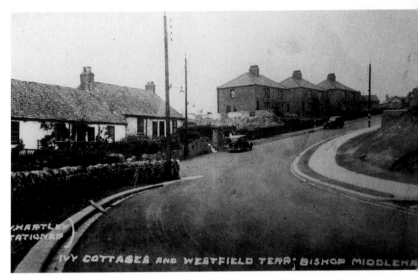

Ivy Cottages and Westfield Terrace, 1935. Built in the latter part of the seventeenth century, these lovely old cottages were once covered with ivy hence their name. Consisting of two rooms, the cottages were demolished and replaced with council houses in 1962. As part of the Council Development Scheme, Westfield Terrace was built between 1930 and 1932.

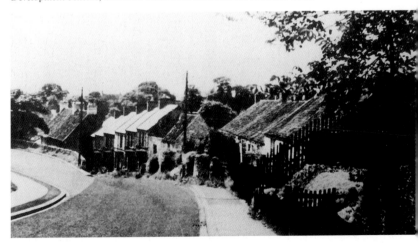

Palmer Terrace and Ivy Cottages, c. 1930. Palmer Terrace takes its name from Thomas Palmer, the village stone-mason who built the street during the early 1900s. The terrace replaced several old houses that dated back to the early 1700s.

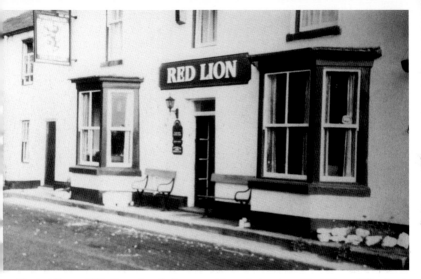

The Red Lion, c. 1982. Situated on the limestone ridge at the junction of Bank Top and Woodstock Terrace, the Red Lion was one of the popular public houses in the village. After its closure in 1993 it stood empty for a while and has recently been converted into four private dwellings.

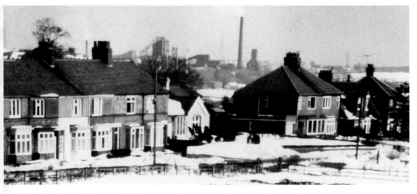

The High Road, March 1979. In the background is Fishburn Cokeworks once a familiar sight on the village's north east horizon. Officially opened in May 1954 at a cost of £2,000,000, the plant closed on 7 October 1986 due to a slump in the steel industry and the importing of foreign coke. The whole complex was blown up in February 1989. A mine shaft was sunk at Fishburn in 1911 and after working for approximately eight years, the colliery closed due to flooding - the old enemy of the Durham coalfield. Re-opened in 1922, it continued working until 1973 when plagued with further water problems, it finally closed down.

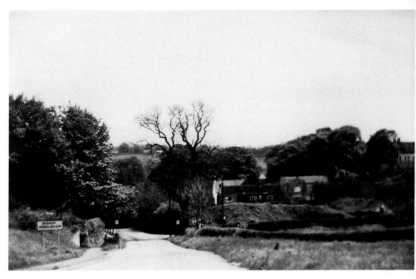

Ancient roads converge on the crossroads below Broad Oak Farm, where evidence of the old medieval Ridge and Furrow ploughing can still be seen.

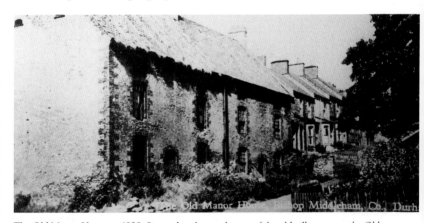

The Old Manor House, c. 1928. Situated at the north west of the old village green, the Old Manor House was probably built at the latter part of the seventeenth century. One half of the building was used as a Halmote Court until as late as 1828, where petty offences were dealt with. Ann Palmer, whose ancestors lived in the village for three centuries, occupied the house until the mid 1950s. To allow access for modern day traffic, half of the Manor House along with the end house in Church Street were demolished in 1956 to widen the road, which had virtually remained unaltered from medieval times.

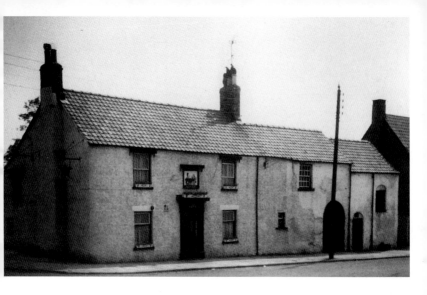

*Above:* The Dun Cow, 1964. The unusual sign above the Inn door, a relic of a bygone age, has been for many years the subject of interest to both villager and visitor alike. A classical example of the Ancient Plaster's art called pargetting or parge-work, it has managed to survive possibly from the late sixteenth century. It commemorates the story of the monks, who on their arrival at Durham with the body of St Cuthbert, inquired of their where-abouts from two milkmaids by the banks of the river Wear. This story has been perpetuated by the cathedral builders at Durham where a carving done by the stone masons can be seen on a north west turret of the Chapel of Nine Alters. The present landlords of the Dun Cow are Grahame Quinn and his wife Tong.

*Right:* Ronald Rodman with his pet labrador pup outside Timor Gittins sweet and tobacconist shop at the top of Well Lane in 1932. Before the advent of piped water into the village in 1886, the womenfolk used the village pump outside the Old Vicarage situated in Church Street, a well below the Brewery and two natural springs in the field close by.

*Left*: Mrs Violet Cooke standing at the front door of Harpers Buildings, *c.* 1940. These houses were condemned and demolished in the late 1960s. Notice the cobbled street which leads towards Garden House. The village had few cobbled streets and this was one of the last to survive. A tarmac road now leads from Bank Top into the residential estate of Stoneybeck which consists of approximately ninety houses erected in 1974.

*Below*: Harpers Buildings, *c.* 1968. Situated opposite to the old Three Tuns public house, Harpers Buildings consisted of six properties thought to have been built sometime during the 1740s. Several survived until the late 1960s, when they were demolished. They took their name from the Harper family who owned the property.

Break Dyke Cottage, c. 1953. Situated near the entrance to the playing field, this cottage took its name from the stone causeway or embankment at the south east tip of Bishop Middleham Castle, which is thought to have been constructed to give access across the moat when the common fields were enclosed in 1693. It is highly probable that stone from the neglected castle was used in its construction. Formerly known as Brigg Dyke Cottage, it was demolished in 1955. The gardener is Bill Sirrell.

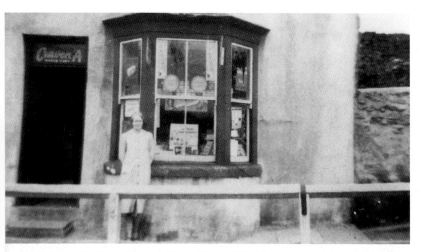

Mrs Shaw outside Maggie Johnson's Corner Shop, c. 1947. This is a far cry from today's modern superstore when simple items like flour and sugar were scooped from barrel and sack. Situated on the corner of High Street and Perm Terrace, Mr and Mrs Tom Cooke owned the premises during the 1950s. After demolition, two council houses were built on the site in 1962.

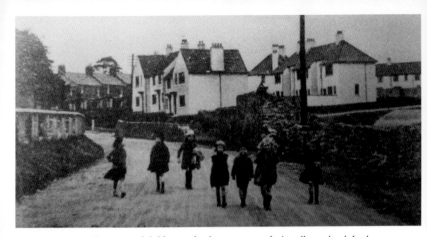

New Town, 1924. This group of children make their way towards the village school. In the background are the Insula Cottages which were built in 1921 by Dorman Long and Company Ltd to house miners and quarrymen. Their unusual name perpetuates the memory of Bishop Robert de L'Isle (of Holy Island) who died in the south east chamber of his castle at Bishop Middleham in 1283.

Hawthorn Terrace, c. 1918. Built during the 1890s, Hawthorn Terrace took its name from the sturdy hawthorn bushes that grew opposite. The towering building at the right of picture is the brewery. During the Second World War, the chimney, whose smoke once gave off a pungent aroma of brewing hops, had to be lowered because it was a potential landmark for German aircraft. The car is believed to be a Ford. Its registration number is DC 481.

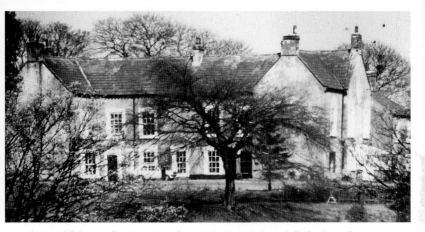

Bishop Middleham Hall, 1978. Situated upon a high south facing hillside, the Hall is a spacious old mansion whose former days of glory are lost in antiquity. Rebuilt in 1761 by Mr George Spearman, it is believed that it replaced a timber constructed Elizabethan House, that was destroyed by fire, which formerly stood on or near the present site. In 1803 John Smeddle is recorded as being Master of the Academy at Bishop Middleham Hall, a boarding school for boys, which is presumed to have been run on similar lines as the notorious Dotheboys Hall immortalised by Charles Dickens.

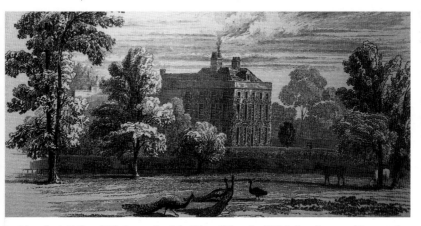

Mainsforth Hall, c. 1823, from a sketch by Edward Blore. In 1708 Robert Surtees of Ryton with his son Edward bought from Ralph Hutton, a bachelor of law at Durham, the ancient estate of Robert de Maynesford. After being badly neglected by the Huttons, Edward, whose father had died in 1710, rebuilt the Hall into a stately looking mansion. It was here, among the stately trees, surrounded by elegant flower borders that looked onto fair lawns, that Robert Surtees wrote his history of the County Palatine of Durham in 1816.

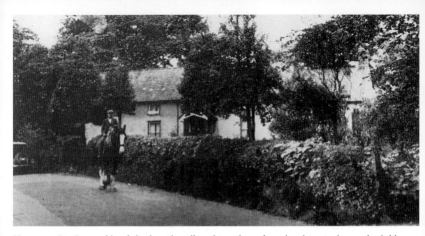

Horseman Jim Reyarnd heads back to the village farm after a days ploughing in the nearby fields in the late 1940s. The charming cottage, now demolished and replaced with a modern bungalow, was formerly the house of Frank Ripley who was for many years chauffeur to General Surtees of Mainsforth Hall. Frank's daughter Gladys still resides in the village.

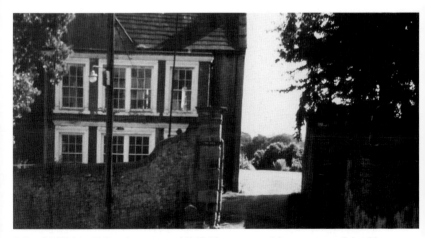

Bishop Middleham Hall in the summer of 1966. This is a view of the west wing and the old gate-piers whose gate opened onto a fair lawn surrounded by well kept flower borders. There was also an excellent vegetable garden maintained by Arthur Bellwood, who was employed by the National Coal Board as the gardener. He retired after twenty-five years service. The Hall is presently occupied by Ralph Blance, a former colliery manager of Bearpark Colliery, and his wife Hilda. Mrs Doris Everett, whose late husband was manager at Fishburn Colliery, resides in the east wing.

Hall Farm, 1968. Shortly after this photograph was taken the building was gutted by Roger Peebles and completely modernised. It was presumed to be within the site of the Manorial Farm first mentioned in 1183. The farm probably lost its title of the 'Manor Farm' during the mid-seventeenth century when all Bishoprics in England were abolished and their various lands ordered to be sold off in 1646. It was almost half a century later that the Enclosure Acts brought about the first enclosure of the common fields around the village in 1693.

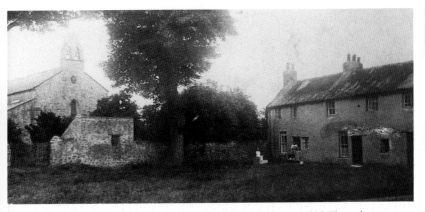

The west gable end of St Michael's church and Hall Farm Cottages in 1935. The end cottage is the probable site of a house granted in 1310 to Bishop Middleham's first vicar, William de Meneres. From the late nineteenth century until 1913, Mr E. Tranmer, a devoted Wesleyan who owned the farm, converted the upstairs room of the middle cottage into a chapel which was used by members of the Wesleyan denomination, until a new chapel was erected in Lower Front Street in 1913. Two cottages were inhabited until the late 1950s when they were condemned. The beautiful oak tree standing a few paces in front of these cottages was planted by Thomas Dunn. It covers what once remained of an old well that survived from medieval times.

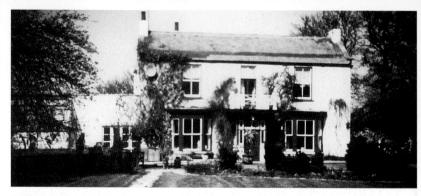

Castle View, the site of a mansion house called Le Front in Le Falde which was owned by Sir George Freville in 1597. During the latter part of the nineteenth century, coal owner George Morson owned the house for a short time. In 1938 Pilot Officer Harry Robson flew his Whitley Bomber low over Castle View to drop messages to his mother. Sadly Harry was shot down over Stavanger in Norway in 1940. His father was Chief Engineer for Dorman Long and Co. and the family occupied the house for a short time.

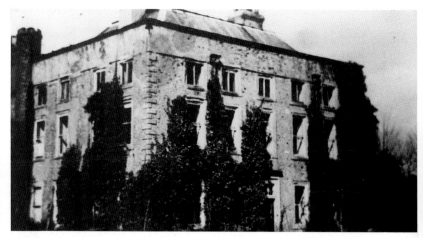

Mainsforth Hall, c. 1947. During the Second World War the Hall was billeted with Army Officers, then later for a short while served as a nursing home before becoming abandoned around 1953. Demolished in 1962, several modern houses now stand on and around the site. All that remains are the north and south entrances still complete with their wrought iron gates, whose supporting pillars are topped with pineapples, a symbol of plenty. On Wednesday, 27 March 1963 the rare appearance of an albino blackbird occurred in the village, its breast was beautifully marked with white flakes. The bird was frequently seen on the wall near the south entrance to the Hall.

A view from Foumarts Lane looking towards the ancient crossroads of Mainsforth and Cornforth. On the far right, a road leads into the Nutgarth Wood which once provided a variety of edible nuts for the Bishop's table. A modern brick built vicarage, which stands at the east part of the wood, was built in 1902 for Revd Matthew Burra Parker, the parish vicar. The present vicarage stands at the edge of Broad Oaks, a new estate built in 1980 by Peter Clark. The present parish vicar is Mrs Val Sheddon.

A picturesque winter scene of Foumarts Lane in March 1979. A few yards below the west gate of the castle and running parallel with the Deer Park Wall, this ancient road was probably extended during the Enclosures as a means of easy access to the various fields situated on the west side of the castle site.

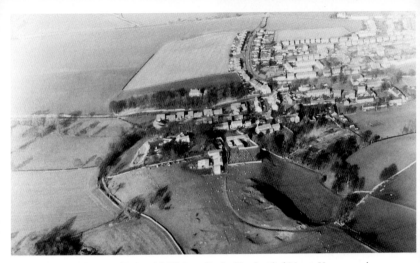

An aerial view of the site of Bishop Middleham Castle. The fortified Manor House was the residence of the Bishops of Durham for almost 300 years from 1099-1381. Two of the Bishops died here in the south east chamber; Bishop Robert de L'Isle (of Holy Island) who held office from 1274-83 and Richard de Kellawe, 1311-16.

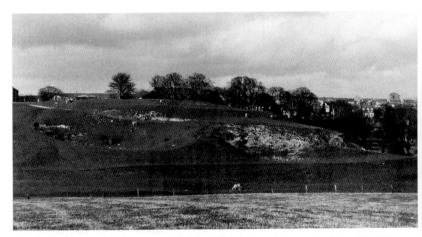

A view of the Castle site from the south. Evidence shows that early Bronze Age Man 1800-1000 BC, along with Iron Age settlers from the La-Tene period, 700-500 BC, were present on this site.

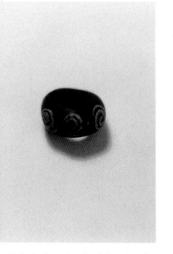

*Left:* An Iron Age Bead found in the grounds of Bishop Middleham Hall in May 1966. The spiral has long been a religious symbol and used by sun worshippers in many countries down through the ages. *Right:* A Jetton coin, bearing the Cercelee Cross, found by Michael Davison, a farmer on whose land the castle remains stand. It was identified by Mr R.J. Brickstock, curator of the Archaeology Department, The Old Fulling Mill, Durham, as being an early English or Anglo-gothic Jetton or Casting Counter which post-dated the introduction of the sterling type penny introduced by Edward I in 1279.

A Capital stone from the gateway of Bishop Middleham Castle, 1969. From the north west, the approach to the castle is flanked by ancient walls that are shaded by hanging beech and chestnut. The site appears to have been chosen primarily for its good defensive position, overlooking what was then, the Skerne marsh. In later years defence became less necessary. The great Warrior Bishop, Anthony Beck, who held office from 1283-1311, favoured the green glades that lay between the Rivers Wear and Gaunless and decided to convert the Manor House at Auckland which remains to this day the official residence of the Bishops of Durham. Son of Walter Bek, the Baron of Eresby in Lincolnshire, Bek was born into a life of wealth and privilege. His personal retinue of knights consisted of no less that 140 men, which suggests that the banqueting hall at Middleham Castle must have been a fair size to have seated so many knights.

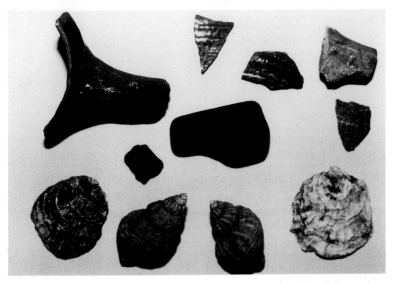

After a flash thunderstorm in the summer of 1985, several pieces of twelfth and thirteenth-century pottery, accompanied by oyster and whelk shells and pieces of coal, were discovered at what appears to have been the kitchen refuse tip of Bishop Middleham Castle.

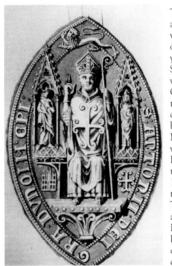

The Episcopal Seal of Bishop Anthony Bek. There are several documents that are dated and bear the various Bishops seals from Middleham Castle. Two of the seals, which have survived for almost 700 years, belong to Bishop Bek. One is the Episcopal Seal showing the Bishop seated in his vestments which clearly display his personal coat of arms, the Cercelee Cross. It can be seen incised upon a stone roundel under the bell tower on the western apex of St Michael's church, forever linking Bek with the building of the church. Incorrectly described as the Moline Cross, this roundel has perplexed historians who have attributed Bek as the builder of the church. Its early English architecture points more favourably to Bishop Richard de Marisco who held office from 1217-26. In 1980 it was confirmed the Cross is in fact the Cercelee, whose splayed arms end with a pellet. The Moline Cross has splayed ends that terminate to a point. The other seal belonging to Bek is that of the Patriarch, for in 1305 as a mark of his special favour, his holiness Pope Clement V created Bek, Patriarch of Jerusalem. Having two horizontal arms, this cross can be seen on the chancel roof at St Michael's.

Robert Surtees died leaving no son to inherit the estate, so that when Mrs Ann Surtees died in 1868, Colonel Charles Freville Surtees of Redworth took over the estate at Mainsforth until his death in 1906. He was succeeded by his only son Brigadier General Sir Herbert Conyers Surtees (right) who on his death in 1933 became the last of the Surtees of Mainsforth. An officer and a gentleman, he distinguished himself in both the Egyptian Campaigns and in the South African Wars where he was mentioned in despatches on several occasions and received many decorations. One of his souvenirs from the Sudan included a brass bell that was part of the head decoration from General Gordon of Khartoum's favourite camel. This stood in the hallway of Mainsforth Hall. As a young man Anthony Eden of Windlestone Hall, who was to become the Foreign Secretary and later Prime Minister of England, was a frequent visitor to Mainsforth where the General taught him the rudiments of the Turkish language. Sir Anthony was noted for his ability to speak at least seven or eight different languages. Among his other interests the General became Provincial Grand Master of the Province of Durham Freemasons in 1932, an office he held for only a short time before his untimely death in 1933.

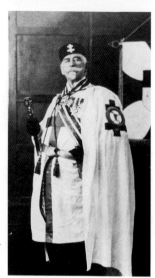

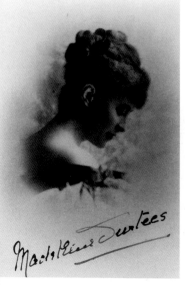

Lady Madeleine Surtees, wife of Brigadier General Sir Herbert Conyers Surtees of Mainsforth Hall. A woman of outstanding beauty Lady Madeleine was also remembered for her gentle and kindly manner, which came to the fore on many occasions. When it was brought to her attention that someone in the village was poorly a basket of fruit would find its way to that house. Shortly after the death of her husband in 1933, Lady Madeleine sold Hope House Farm to Charles Marshall's mother with whom she became good friends. The present farmhouse was built in 1922 by General Surtees whose coat of arms is built into the North Gable end. It stands a short distance from the old farm which still retains vestiges of the old barns. Today Mr and Mrs Charles Marshall and his brother Fred continue to run Hope House. Their son Charles manages Broad Oak Farm, also built by General Surtees in 1925, named after one of the family estates in the Tyne valley.

Miss Annie Bellerby, the daughter of Ralph and Ann Bellerby who held the land at Hall Farm during the 1870s. Situated within the shadow of St Michael's church, this ancient farm is believed to have its origins in the latter part of the twelfth century when in 1183 there is mention in the Bolden Book that the Lordship Farm is in the hands of the Bishop himself. Compiled in 1183 by the instruction of Hugh de Pudsey, Bishop of Durham from 1183-95, the Bolden Book is similar to the Domesday Survey which was launched at the Christmas Court held by William the Conqueror in 1085. The Fish Pond field and those below Broad Oak Farm still show evidence of the old medieval ridge and furrow farming. Edward Tranmer, one of the original members elected to the Parish Council in 1894, bought Hall Farm during the 1890s. After almost sixty years in his family the land was leased in 1952 to Fred Davison and his sons Thomas and Albert. The farm is now owned by Albert, his son Michael and nephew John, who continue the family tradition.

William Stacey, born in 1847, devoted his life to gardening. He became Head Gardener to Brigadier General Sir Herbert Conyers Surtees of Mainsforth Hall. After a life time of loyal service the General commissioned an artist and had his portrait painted to mark fifty years service. Founded in 1883 Bishop Middleham Horticultural Society was organised by William Stacey who was also its first secretary. The Horticultural Show is believed to have been held in a large marquee which was situated in the field just to the south of the old school where the Park Estate now stands. Until recent times, his son Rendall and his wife Hazel, along with daughter Zoe, ran a market gardening business at Mainsforth. They were widely known for their expertise, in particular for making wreaths and floral tributes.

Betsy Ann Palmer, c. 1920. She gave her life to the church and her kindness and generosity was exceeded only by her personal devotion and love of Christ. She was a direct descendant of the village's most famous son, John Palmer, 1785-1846. On leaving the village at sixteen years of age, John was bound as an apprentice stone mason to his uncle at Durham. He was illiterate and signed his indenture with a cross. Having mastered being able to read, write and draw, he became a self taught architect and went on to build Pleasington Priory in 1816-18, the beautiful cathedral of St Mary's at Blackburn in 1820 and a number of other churches. Although Betsy's grave is unmarked, a coloured memorial window bearing Bishop Anthony Bek's Cross Cercelee looks down upon the font in the north west corner of St Michael's church. Having helped with the upkeep of the church fabric she also helped to provide the village with the new school built in 1969 along with the land it was built upon. The village is indebted to her generous nature.

Miss Evelyn Nobbs standing outside her parents home at No. 4 Upper Front Street, around 1914. Along with her sister Mary, she served as a nurse in France during the First World War. Four women left the village for war service. The other two were Dora Forster and Florence Gittens. During the Second World War the following list of women served in the various branches of His Majesties Service: B. Blythe, G. Dove, D. Duffield, M. Hutchinson, I. Jones, I. Owens, J. Patchett, S. Robson, M. Sayers, E. Smith, N. Smith and D. Watson. This list may be incomplete, and the author therefore makes his apologies in anticipation to anyone not included.

The author holding the R.W. Davison Memorial Trophy provided by the Parish Council. A history of Bishop Middleham would be incomplete without paying tribute to the late Ralph Davison. For many years he was a member of the St John's Ambulance Brigade and was stationed at the Fishburn Depot with the Ambulance Service. Ralph joined the Parish Council where he accepted the position of Vice Chairman and it was in this capacity that he decided to re-introduce the Village Horticultural Show which had dwindled away in the late 1960s. Sponsored for its first year by the Parish Council, who donated £800 towards the costs, exhibitors competed for eleven trophies provided by local business people and £600 in cash prizes. The show was over two days and held in the village hall. Trophies were presented at 4.30 p.m. Sunday, 7 September 1986 by Tony Blair MP for Sedgefield. Sadly Ralph died on 1 May 1986.

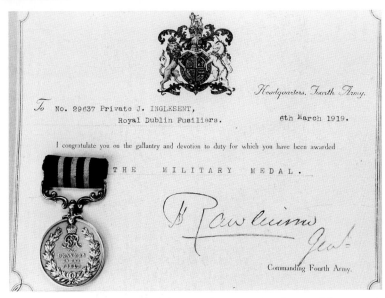

For Bravery in the Field. The citation reads, 'I congratulate you on the gallantry and devotion to duty for which you have been awarded The Military Medal'. Joe Inglesant was a quiet, modest type of man. He was well liked at Mainsforth Colliery where he was employed in the sawmill. While serving in the trenches with the Royal Dublin Fusiliers during the First World War he was ordered to deliver an important message, while under heavy machine gun-fire from the enemy. Thought to have been an impossible task, he survived to receive his award. On his retirement Joe moved into one of the new bungalows built in The Park at Bishop Middleham.

*Three*

# Religion

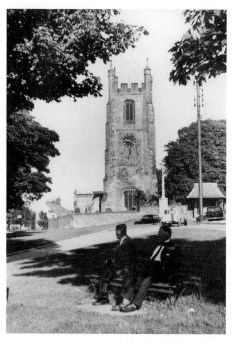

St Edmund's, Sedgefield parish church. This scene shows two gentlemen sitting in the shade at the west front of the church. This part of the green was the site of the original mediaeval market. The lych gate was erected in 1907 and dedicated to the Thompson family.

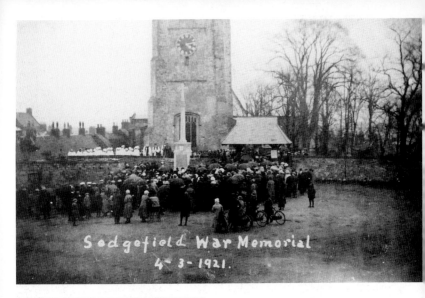

Sedgefield War Memorial
4 - 3 - 1921.

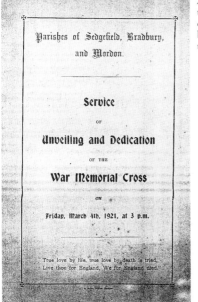

Parishes of Sedgefield, Bradbury,
and Mordon.

Service

OF

Unveiling and Dedication

OF THE

War Memorial Cross

ON

Friday, March 4th, 1921, at 3 p.m.

"True love by life, true love by death is tried,
Live thou for England, We for England died."

*Above and left:* The unveiling and dedication of
the Sedgefield War Memorial Cross took place
on Friday 4 March 1921. The Cross was unveiled
by Lt. Col. Vaux, DSO, CMG and dedicated by
the Lord Bishop of Durham.

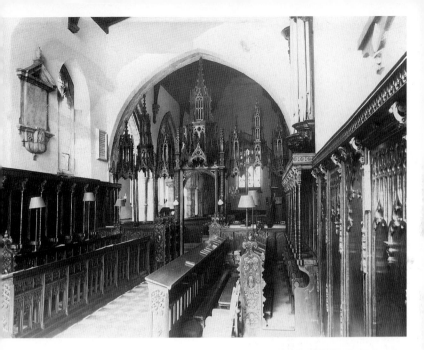

*Above:* The Chancel at St Edmund's was built around 1290. Notice the addition of the front choir stalls. These front prayer desks were given by the Cathedral at Durham as St Edmund's was the only church in the diocese large enough to accommodate them. The beautiful tiled floor remains uncovered today.

*Right: Above:* St Edmund's church interior looking east. The screen is an example of Elizabethan woodwork from the time of Bishop Cosin who furnished the choir of Durham Cathedral.

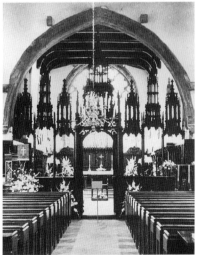

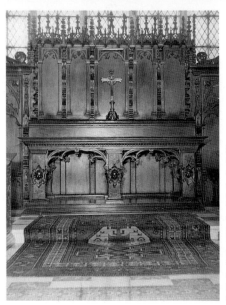

St Edmund's church showing the altar with its fine carving. Although the present church dates from the mid-thirteenth century, there are records indicating a church here during early Norman times. The ninety foot tower, visible from all directions from several miles away, was not added for another two hundred years. Until a few years ago, a curfew bell was rung from the church tower at 8 p.m. in winter and 9 p.m. in summer. Inside the church, notable features include an ornate screen dividing the chancel from the nave and some interesting brasses.

The interior of St Edmund's church showing the carved capitals on one of the columns. In the background is one of the two brasses which shows a male and a female skeleton wrapped in shrouds. In addition, a famous brass of a kneeling lady, dated from 1310 is worthy of note; especially since it was stolen in the 1970s and was rediscovered in a Scottish pub a number of years later.

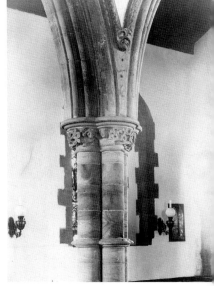

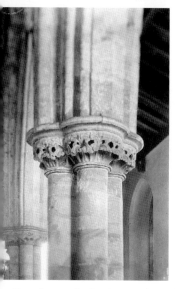
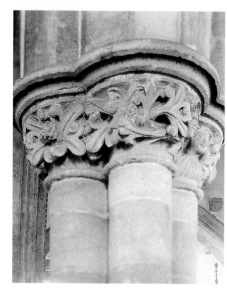

Four photographs showing carved capitals from the interior of St Edmund's church.

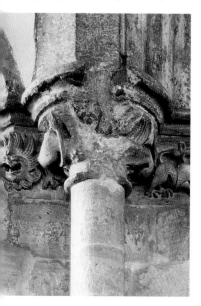
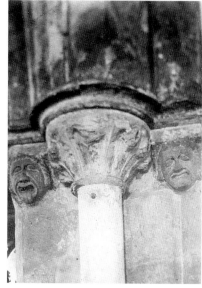

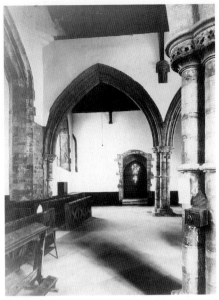

*Left:* The north door of the parish church clearly shows the pattern of holes deliberately let into the wood in order to let the devil out. Later the door was barred to keep him out permanently.

*Below:* St Edmund's Mothering Sunday procession. The choir processed from the old Rectory down Rectory Row, along Cross Street, turned left into the High Street and then across the green to the church. Notice the all male choir and the posies carried by the children.

*Opposite above:* The High Street, Sedgefield, looking towards Church Row. The Roman Catholic church of St John Fisher, dating from the 1930s, is on the left.

*Opposite below:* Sedgefield Church Lads Brigade, 1909. The leader is Mr Swainston. This group appears to be posed in front of an arch in the Rectory.

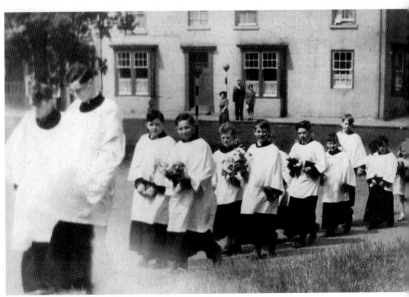

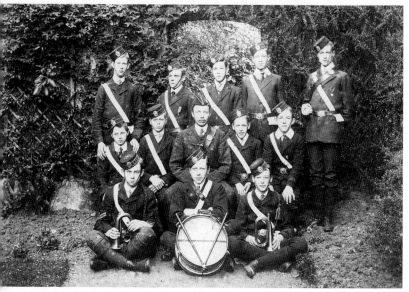

The Wesleyan chapel, West End, Sedgefield.

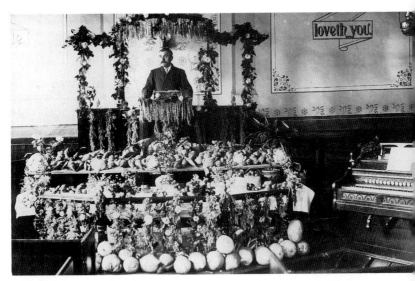

Harvest Festival at the Wesleyan Methodist chapel. The chapel was erected in 1856 but subsequently closed for worship and is now used as the local Scout Hall. The chapel was on the site of an earlier building built around 1812.

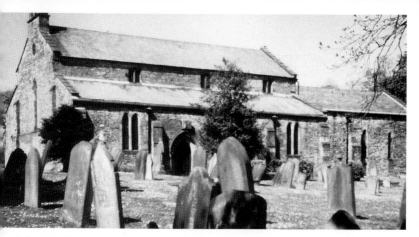

Bishop Middleham Parish Church, 1967. A wander around the churchyard reveals the gravestone of Robert Surtees, 1779-1834, Historian of the County Palatine of Durham. Close by in an unmarked grave lies Robert Oswald, 1729-1822, a sergeant in the 58th Regiment of Foot. He scaled the heights above the Plains of Abraham to capture Quebec with General James Wolfe on 13 September 1759.

Enhanced by floodlighting this beautiful winter evening scene of St Michael's church, Bishop Middleham, is taken from the north east corner of the churchyard, showing the nave and early thirteenth-century porch. According to legend the north west corner of the old churchyard, which lacks any gravestones, is the burial ground of several people from Cornforth who died of the plague during the winter of 1645. It is recorded that an outbreak of the plague occurred at Durham City the previous year. The floodlights were installed in 1983.

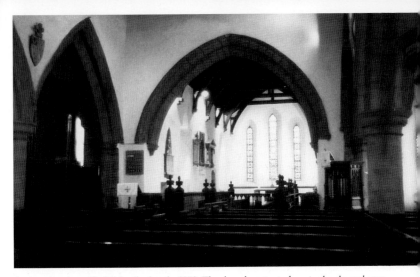

An interior view of St Michael's church, 1970. The three lancet windows in the chancel were inserted by Mrs Anne Surtees in 1842. Daughter of Ralph Robinson of Herrington Hall, she married Robert Surtees of Mainsforth. The memorials are to Marshall Robinson, Robert Surtees and Mary Ann Page.

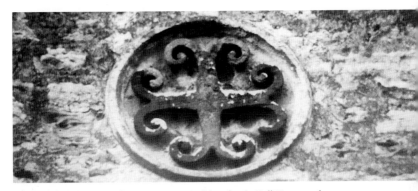

The Cercelee Cross incised upon a stone roundel under the Bell Tower on the western apex of St Michael's church, forever linking Anthony Bek with Bishop Middleham. Shortly after being installed as the Bishop of Durham in 1283, Bek soon established himself as a military commander during the wars against Scotland when he became the Warrior Bishop. In an effort to lure Robert the Bruce into England it was Bek who had Bruce's wife and daughter hung in cages from the castles at Holderness and the Tower of London. In 1307 Edward the Second granted him sovereignty of the Isle of Man. He was the first Bishop to be buried in the Durham Cathedral near Cuthbert. All his predecessors having been buried in the Chapter House.

Situated above the doorway of the porch of St Michael's church, now badly eroded and almost unrecognisable by the hand of time, this beautiful thirteenth-century floriated grave cover was recorded in 1970 by the author. As a perpetual reminder of the immense skill of the medieval mason, Bishop Middleham history society decided to adopt the design as its logo. The local history society held its first meeting in the village hall on Friday, 11 November 1966 when nineteen people attended to become members. They elected as President Newton Haile, Chairperson Mrs Dorothy Turner, Secretary Frank Bellwood and Treasurer Freda Coates. A few months later the membership increased to thirty-five people. The annual subscriptions were set at 2/6d (12½p) and members contributed 6d towards the societies funds. Celebrating its thirtieth anniversary on the 8 November 1996 the society still maintains a membership of just over thirty members.

From ancient times the use of geometry and numbers has been applied to erect not only our magnificent cathedrals but also our simple country churches. For example, in the symbolism of church planning it is not by chance that all Christian churches are orientated from the rising to the setting sun; with the chancel pointing to the east and usually fitted with three lancet windows to remind the congregation of the trinity. Alter stones were incised with five Greek crosses to represent the wounds of Christ. Usually placed by the main door, baptismal fonts from Norman times were made octangle shaped, the figure eight being a symbol of resurrection and new life. This symbolism was also extended to the monumental mason's craft. Situated in the porch at St Michael's this unique thirteenth-century grave cover thought to be that of an abbot, has been interpreted as follows: the five interlaced horseshoes, left, symbolise Christ while the three uncoupled represent the trinity when conjoined they would symbolise resurrection and new life. Bottom right are two mason marks found within the church.

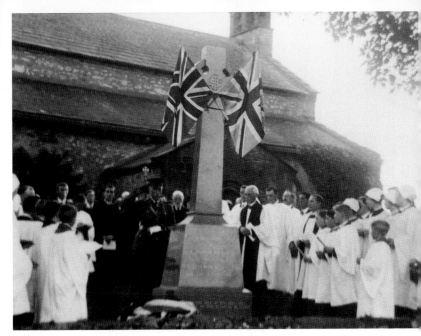

St Michael's Churchyard, October 1920. General Sir Herbert Conyers Surtees of Mainsforth Hall pays tribute to the men of the parish who fell in the First World War. The Revd W. G. Davison officiated the service held during the unveiling ceremony of the War Memorial raised from public subscriptions. The memorial is in the form of a Celtic cross. Below, a stone tablet in the form of a book records those who fell in the Second World War.

Those who fell in the 1914-1918 Conflict
R. Barton, P. Bell, R. Bulman, J. Burney, A. Campan, J. Crake, G. Duffield, A. Davison,
F. Hirst, W.T. Hutchinson, R.W. Johnson, T. Laverick, J.S. Lee, T.T. Legge, J. Maddison,
T. Murray, P.D. Robinson, A. Smith, G.S. Taylor, J.W. Walker, J. Watson.

Those who fell in the 1939-1945 Conflict
P.B. Haile, H. Hodgson, H. Robson, B. Sayers, H. Dodsworth, I. Jones, W. Moralee, L. Hewitt.

*Four*

# Schooldays

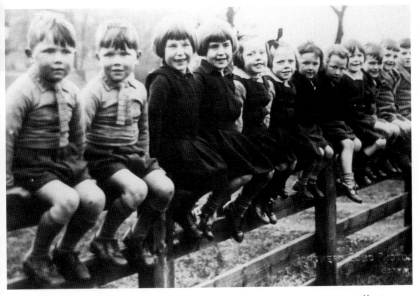

In 1940 Bishop Middleham Church of England School was in the unique position of having six sets of twins attending for their education. The children are, from left to right: the Dixon, Lincoln, Turnbull, Weston, Ross and Wheaton twins. The Lincoln twins were evacuee children who came into the village during the Second World War.

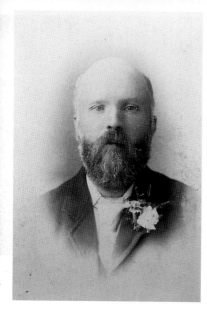

Born in Cumberland in 1844, Mossop Haile was left an orphan at the tender age of ten years. After a short period as an assistant teacher he applied and was accepted to the post of Head Teacher at Bishop Middleham Church of England School. He married Maria Elizabeth, the eldest daughter of Ralph Bellerby who farmed at Hall Farm close by St Michael's church. He became the first of three generations of the Haile family to hold this position. He served the school from 1868-1909.

When his father retired from the school in 1909, Alfred Mossop Haile succeeded him into the position of Head Master. He served the school for thirty six years from 1909-45. Like his father he took great pleasure from his garden where he devoted much of his spare time growing both vegetables and flowers. He was seldom seen about the village without a colourful bloom in his button hole, a custom that was once much favoured by his fellow countrymen.

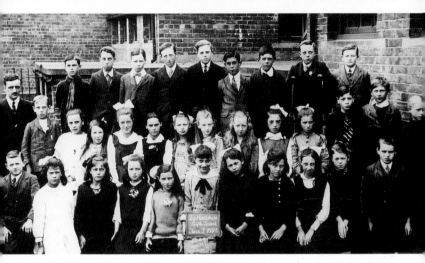

Bishop Middleham Class 1 of 1920, with Mr W.H. Smith, who taught at the old school from 1914-47. Having served in the First World War at Gallipoli in 1915, he was one of the fortunate ones who lived to be evacuated several months later. He was with great affection known as 'Bollie' to later generations of Bishop Middleham children.

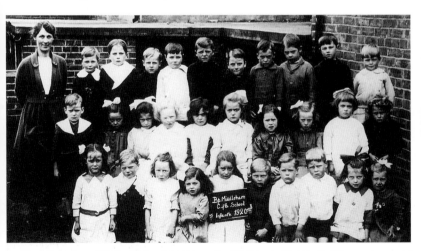

The infants class of 1920 at Bishop Middleham C. of E. School with Miss G. Gibson, who taught at the old school at the edge of the village green from 1904-27. Those identified so far are: Jeane Davison, third from the left in the front row, with Rendall Stacey and Newton Haile, third and fourth from the right in the back row.

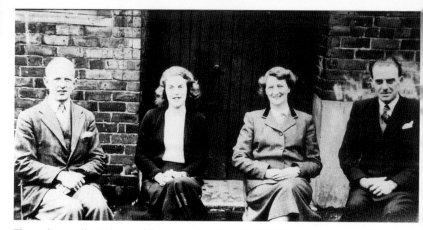

The teaching staff at Bishop Middleham C. of E. School in 1948. They are, left to right: George Fleming, Jean Rutherford, Margaret Barker, and Raymond Walker. A well known figure in the community and a gentleman in every sense of the word, Raymond, played the church organ at the village church for many years.

Bishop Middleham C. of E. School, Class of 1950. The teachers are Mrs Cuthbertson and Mr N. Haile. The pupils are, back row: O. Ross, P. Rutherford, D. Smith, P. Clarke, C. Robson, J. Rutherford. Middle row: E. Gargett, J. Lawson, J. Clark, O. Dunn, S. Ross, J. Hufford. Seated: J. Walker, J. Holdsworth, W. Johnson, P. Smith, M. Sirrell, D. Hufford.

Bishop Middleham C. of E. School, Class of 1958. Back row, left to right: J. Elgey, A. Scott, N. Johnson. Middle row: W. Hindmarsh, D. Crowther, J. Smith, A. Nobbs, L. Hutchinson, R. Stewart, K. Dove. Front row: J. Hammond, K. Patton, J. Pybus, N. Forbett, D. Foster, Mr Arthur Lister, J. Elsey, H. Graham, D. Labron, M. Tinkler, J. Pybus.

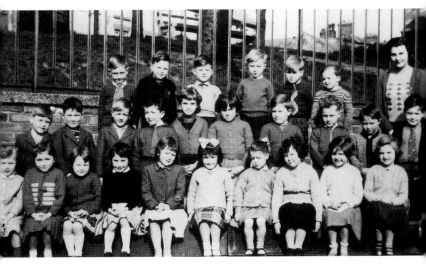

Bishop Middleham C. of E. School, Class of 1960. The teacher is Mrs G. Haile. Back row: D. Shaw, A. Burns, M. Healey, J. Davison, B. Healey, J. Pybus. Middle row: A. Bellwood, P. Atkinson, D. Tattersall, D. Wallace, E. Gibson, V. Coates, B. Auton, C. Ranson, R. Patchett, S. Reed. Front row: G. Edwards, A. Jones, L. Pennington, S. Auton, G. Jones, E. Meggeson, L. Cutler, C. Nobbs, M. Gash, L. Watson.

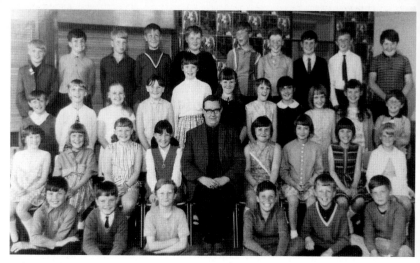

Bishop Middleham C. of E. Junior and Infant School, 1969. Front row, left to right: A. Nordman, J. Watson, D. Tate, A. Reed, P. Bellwood, J. Howson. Second row: F. Moffat, S. Tate, L. Pennington, J. Cooke, Mr D. Crookes, S. Patchett, S. Meggeson, S. Lawson, L. Turnbull. Third row: J. Pybus, J. Brabbon, T. Jackson, S. Bellwood, A Turnbull, J. Sheehan, J. Tattersall, J. Watson, C. Rodman, P. Jackson, G. Shaw. Back row: J. Mathews, D. Henning, A. Redhead, R. Tonge, T. Calder, C. Marshall, B. Gargett, M. Corbett, K. Defty, M. Wallace.

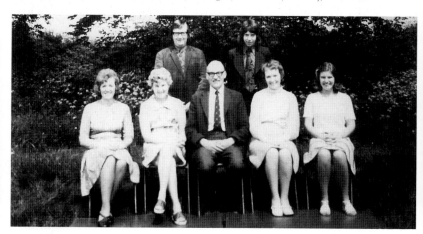

Bishop Middleham Church of England School, teaching staff, 1978. Standing, left to right: David Crookes, Harry French. Seated: Bernice Hope, Gladys Haile, Newton Haile (Head Teacher), Joyce Defty (Secretary), Norma Hull.

Bishop Middleham C. of E. School Class of 1987. The teacher is Mrs B. Hope. Back row, left to right: L. Murray, C. Wright, J. Whitby, M. Nobbs, D. Bentley, C. Poulter, N. Morrin, D. Bowman, S. Gibbon. Middle row: K. Davison, M. Siddle, E. Chamberlain, K. Lyne, G. Anderson, G. Glendinning, C. Dove, N. Scott. Front row: C. Dove, A. Davison, B. Stockdale, R. Weddle, K. Davison, C. Hornsby, K. Noades.

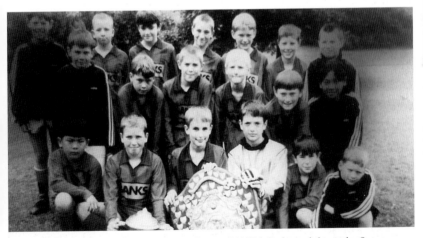

Bishop Middleham C. of E. School Football Team, 1995-96. Back row, left to right: Stuart Lawton, Craig Pickering, Paul Frith, Keith Curbison, Mark Alderson, Jonathan Hornsby, Jamie Jones. Middle row: Andrew Barker, Robert Starkey, Gareth Hamblin, Steven Dove, Kriss Shaw, Barbara Quinn. Front row: Paul Quinn, Jack Shaw, Robert Lister, Phillip Waddelton, Peter Round, Christopher Tumlin. The trophies are the National Orphanage Cup, The League Winners Shield and The Kelloe District 5-a-side Shield.

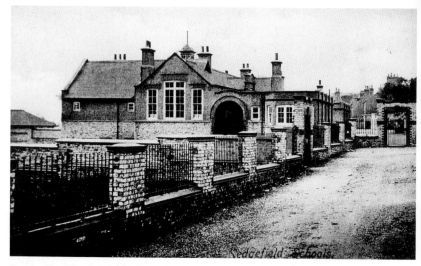

Rectory Row School. Sedgefield Junior School was built in 1909 as a mixed sex school. Notice the unusual architecture. In the past twenty-five years the building has been updated and modernised to cope with the growing population of the town.

This photograph was taken either the year Rectory Row School opened or the following one. Lace collars were worn by children of both sexes.

*Above:* Rectory Row
School, Sedgefield. A
similar photograph taken
approximately twenty years
later shows how the children's
fashions have changed to a
more practical mode of dress.

*Right:* By the 1930s the children
had adopted the wearing of
school uniform at Sedgefield.

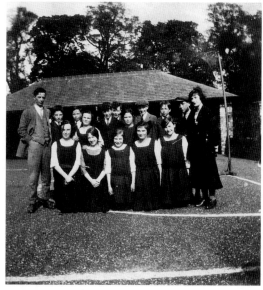

A typical class register from a Sedgefield School dating back to 1856.

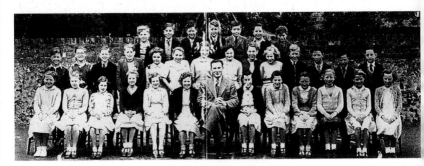

Rectory Row School, Sedgefield in 1956. Mr Risler is the teacher.

*Five*

# Working Life

Pipe layers taking a break outside the Hardwick Arms at the beginning of the twentieth century. Most of these workers would be employed by the Hardwick Estate. Notice the prevalence in those days of moustaches, beards and a flat cap as a 'uniform' for the men.

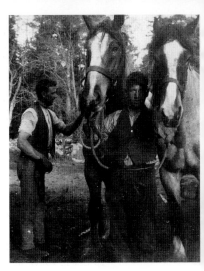

Left: Hay making the old fashioned way at a Sedgefield farm. The creation of haystacks of some magnitude, where even the ladder does not reach the top, seemed to be the order of the day. Right: Two magnificent shire horses. These animals were essential to local farmers before mechanisation took over. They tower above the two farm workers giving an idea of their huge size and strength.

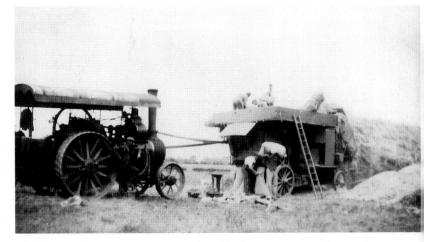

An old steam driven threshing machine. Machines like these were not owned by every farm. There may have only been one in the locality which was hired out to neighbouring farmers by its owner. The same procedure occurs today with combine harvesters.

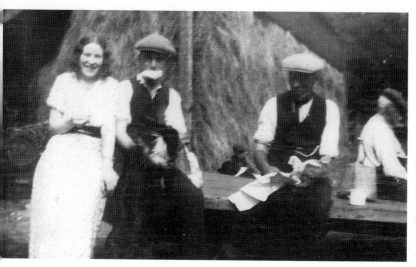

Refreshments in progress during haymaking near Sedgefield. Note the young lassies smile and the unusual addition to the gentleman's mouth.

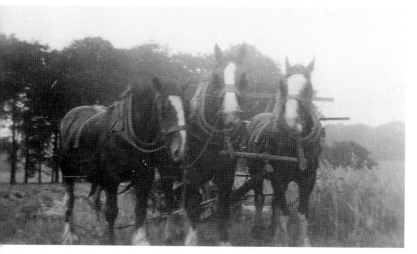

It may have taken longer but there was a certain romance in ploughing with three beautiful horses. Life had a rhythm which later in the century was overtaken by technology.

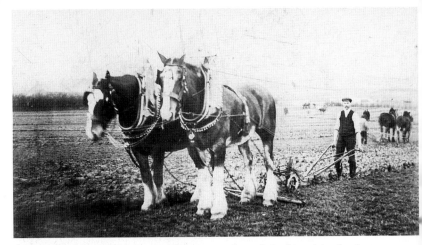

The elaborate halters, etc. of the two shire horses together with the dress of the ploughman would perhaps indicate that this photograph was taken to commemorate a ploughing competition. Many hours polishing and grooming would have taken place in preparation for this event. Not only would the ploughman's ability to plough a straight line have been taken into account but also the way in which his horses were 'turned out'.

A Sedgefield farmyard scene where even the horse looks as if it is posed. Waistcoats with gold chains were standard wear even when labouring.

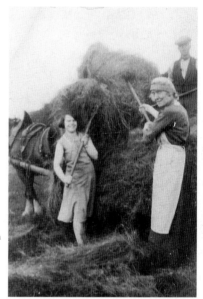

*Right:* Haymaking at Brakes Farm in the 1930s. The tenant farmer was Mr Barron, father of Jean Barron, young lady on the left.

*Below:* Celebrating the end of haymaking. The farmers, their hands, and their families pose in front of the new hay ricks.

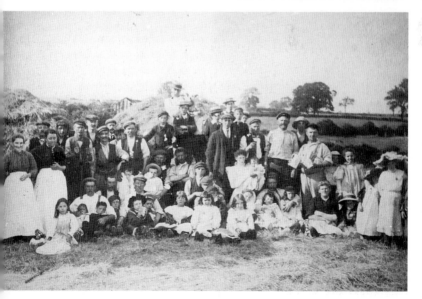

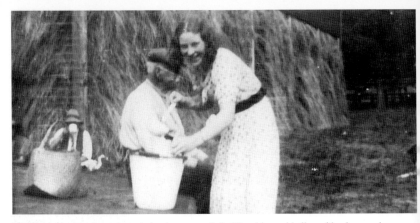

The thirsty workers being attended to by a young lady. The old metal ladle and bucket may have been less than hygienic but the radiant smile makes up for it all.

Adjustments being made to the 'Grim Reaper' a most lethal piece of machinery. A 'Remarkable Event' occurred on 17 July 1792 which caused chaos in the local farming community and the rest of the population. It is recorded in Local Records Volume I by John Sykes: 'A very singular and destructive ice storm occurred at Sedgefield, in the county of Durham, and its neighbourhood. It happened between the hours of eleven and one in the day, and was preceded by an almost total darkness, and a noise resembling reverberated thunder. The streets in the town were filled to a depth of two feet with pieces of rugged ice, varying in size from that of a marble to the bigness of a man's head. All the windows which had a southern aspect were entirely broken, and many houses presented a dreadful picture of its violence and devastation. It began near Preston, and continued to rage in a south-east (sic) direction to beyond Kelloe. All the corn exposed to its fury was destroyed. The trees were stripped of their leaves, numerous birds were killed, and the cattle broke from their pastures, and, with visible expressions of terror, fled to the habitations of man for security.'

*Right*: Machines broke down on a regular basis and farmers had to be 'mechanics' too. Here, two men repair an old binder on a Sedgefield farm. This machine automatically cuts the corn and binds it into a sheaf.

*Below*: Ploughing with an early tractor. The waterproof mackintosh and leather gaiters are a far cry from todays wax jackets and wellington boots, though there is little change in the headgear.

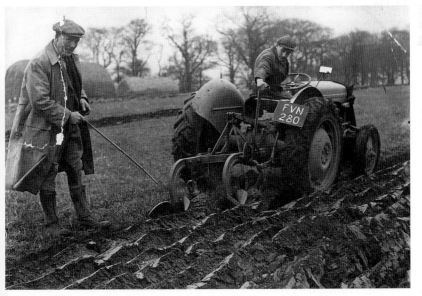

James Dove of East House Farm with his daughter Mary and son William. Born in 1834, James came to Bishop Middleham in 1881. He was succeeded by a further three generations of his family who have farmed the land at East House for well over 100 years. The farm now remains in the hands of his great grandson Frank. After the Parish Councillors Election Order of 1894 he became one of the first of the seven men duly elected. He served for two years. The other six men were John Gibson, Master Brewer, William Gibson, Mental Hospital Worker, George Lee, Post Master and Grocer, Thomas Palmer, Builder and Mason, Edward Tranmer, Farmer, and Robinson Westgarth Crowther, Blacksmith. Records show that in 1828 John Miller held East House Farm.

Thomas Davison and his wife Mary of Farnless Farm, Bishop Middleham, c. 1924. They are one of the oldest farming families in the parish. The Davisons are recorded at Hope House Farm in 1864 where Thomas Davison is mentioned as a member of Bishop Middleham Association For the Prosecution of Felons, an organisation formed to help prevent damage to property and the stealing of animals and crops. Tenant farmers to the Surtees family of Mainsforth Hall, the Davison family were offered Farnless Farm and moved there in 1910. Their daughter Dorothy, Mrs Turner, became a teacher and taught at the village school for a short time during the mid 1960s. Joining the Parish Council in 1934 she became one of its longest serving members after serving for over forty-two years. Thomas' grand daughter, Daphne Calder is presently vice chair of Bishop Middleham Local History Society.

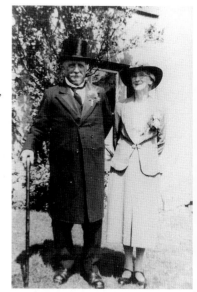

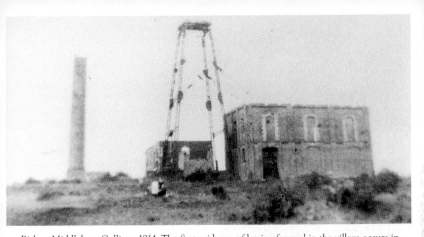

Bishop Middleham Colliery, 1914. The first evidence of boring for coal in the village occurs in 1840 when boreholes were placed in the vicinity of The Park. However it was not until 1842 that a shaft fourteen feet in diameter was sunk to a depth of four hundred and twenty-six feet at approximately five fathoms below the main coal seam, whose average height was three foot eight inches. It is believed that the mine belonged to a Belgian company who later sold out to the Weardale Coal and Iron Company which was formed in 1844 by Durham Ironmaster, Charles Attwood. Both the Hutton and the Harvey seams were worked as early as 1870 and workings ceased sometime in 1878, when the colliery is believed to have closed due to water problems. However a low state of trade in the coal industry was being experienced at this time which led the coal owners to demand a reduction of twenty per cent on miners wages. This may well have accelerated the colliery to close down. In 1914 all that remained of the colliery on the surface was the frame belonging to the old headgear that supported the pulley wheels. The winding engine house, lamp cabin and chimney which was part of the boiler house complex which provided the steam to drive the winder. The chimney was demolished in 1928. As a boy Clifford Webster, who was born in the village, remembered seeing it fall. Having installed an electrically driven winder, Dorman Long and Company, who had bought the colliery, re-opened the shaft in 1928 for the purpose of riding men and ventilation. An explosion at the shaft bottom in 1930 closed the colliery until July 1932, by which time it was connected underground to Mainsforth Colliery by a drift to the Harvey seam at a depth of eight hundred and fifty four feet. The National Coal Board took over the colliery in January 1947 and by 1950 approximately four hundred men were riding daily at the shaft. They were transported by bus to Mainsforth Colliery baths where first class bathing facilities were available. When working became more concentrated the shaft ceased to be used and consequently it was officially closed down when the last shift of men surfaced on 23 May 1958. Ten houses were built near the pit in the early 1840s known as Sinkers Row from the men who sunk the shaft. They were situated close to the Old Clay Pit which supplied the materials for the Brickworks nearby. A further eight houses were added to make a row of eighteen houses whose earth closets fronted the old wagon-way that lead into the colliery yard. Shortly afterwards a further ninety-nine houses were built making a total of one hundred and seventeen. Typical in the layout of a nineteenth-century colliery village, the houses were placed in six long rows (Raas) and with the exceptions of the official houses and those at Sinkers Row the rest were never occupied. After many years of being derelict they were finally pulled down shortly after the First World War and Sedgefield Rural District Council built Woodstock Terrace in 1921-22 from the bricks.

These men are outside the Engine House at Bishop Middleham Colliery within a few days prior to the explosion that occurred on Sunday evening, 2 March 1930. They are, left to right: Edward Turner (Lamp Cabin Attendant), Tom Cooke (Banksman) and Ellington Brewster (Winding Engineman). Having been offered the position of winderman, one of the most responsible jobs at any coal mine, Ellington Brewster commenced work in the Engine House in January 1930 and remained winderman until 1946. His son-in-law Harry Harley, who still lives in the village, held the position from 1956 until the colliery closed. The shaft was left as a means of escape from Mainsforth Colliery until June 1966 when it was filled in. After a settling period the final concrete capping took place in 1988. After a chequered history of almost one hundred and twenty years the beautiful Rose Bay Willow Herb now grows in great profusion on ground that once echoed to the sound of clogs and hob nailed boots. Two short concrete bollards now stand on the old heapstead. The one nearest to the village marks the site of the man riding shaft, the other stands upon the fan drift or ventilation shaft.

Colliery Houses, Bishop Middleham, c. 1954. Built during the early 1840s these houses formed part of a block of four houses that were intended for use by colliery officials. They cost £50 to erect and their rent was £5 per annum. They survived until 1969 when they were demolished. The children are, left to right: Ann Patchett and William Sirrell.

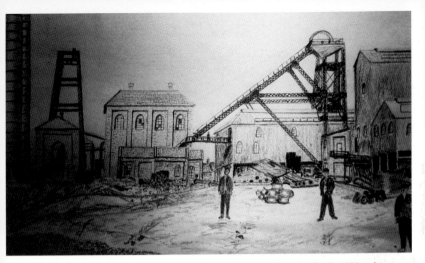

*Above:* Mainsforth Colliery, 1921, from a sketch by village artist Tom Cooke. In 1873 sinking commenced at both the East and West Shafts. Unfortunately work was abandoned in 1877 due to a sudden inrush of water after the West Shaft had been sunk to a depth of two hundred and seventy feet. The company went into liquidation and the plant equipment was auctioned.

Consequently the shafts were used as rubbish dumps until 1904 when the Carlton Iron Company, who were working a mine at nearby East Howle, acquired the mining lease and deepened the fourteen feet diameter shafts to the Harvey Seam at eight hundred and fifty-four feet. The colliery commenced coal production in 1906. In 1923 Dorman Long and Co. took over the mining lease from the Carlton Iron Company and ran the pit until January 1947 when the mine came under the direction of the National Coal Board. On the 29 September 1968 an inrush of water occurred in the Low Main Seam which produced approximately 2,500 gallons of water per minute and within a short period this amount almost doubled. Unable to cope, the decision was made to close the mine and production ceased on 7 December 1968.

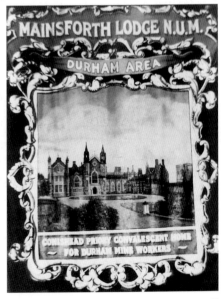

*Right:* Mainsforth Colliery Lodge Banner.

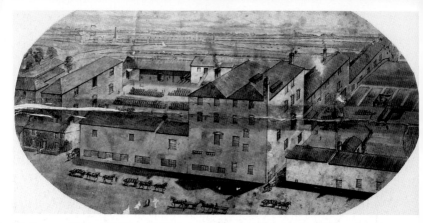

The Brewery, Bishop Middleham. A Brewery existed in the village as early as 1700 and parish records mention William Subert as the Common Brewer in 1759. Anthony Reed, a wealthy business man, owned the Brewery in 1820 along with Hall Farm. In 1826 his brother Robert took it over. He in turn, sold it to a family called Hodgson who married into the Forster family. This sketch of the 1813-26 Brewery was drawn sometime between 1842 and 1899. Notice the colliery and rows of houses in the background. The colliery shaft was sunk in 1842 while this Brewery burnt down in 1899.

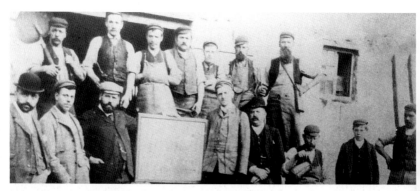

The staff in the Brewery Yard, c. 1894. Charles Frank and Douglas Forster are holding a map of the County which displayed the various public houses where their beers were being distributed to. In August 1892 Douglas Foster managed to survive a horrific injury when both arms were torn from his body by some of the machinery in the Brewery. However, he was undaunted by this terrible accident. He was a very popular and likeable man, and served on the parish council for almost forty years, from 1910-49. He is perhaps best remembered for directing many of the very enjoyable plays that were held in the old school. Charles Walker, who lived on High Street and used to help in dressing his wounds, recalled that Douglas would say, 'Rather it happen to me, than one of my men'. It shows the measure of his courage and unselfish character.

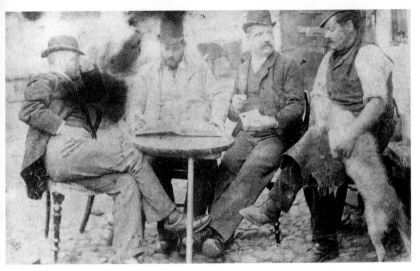

The Brewery Yard, Bishop Middleham, *c.* 1860. Charles Frank and Matthew Forster check the payments book, while seated at the payout table, where in the early days the men and boys received their wages.

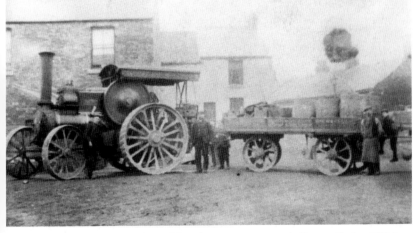

A fully laden dray wagon stands coupled to the traction engine in the Brewery Yard, *c.* 1896. It was these engines that replaced the magnificent Cleveland Bay horses, that formerly pulled the drays. After extensive development in the 1820s, these buildings were destroyed by fire on New Years Eve 1899.

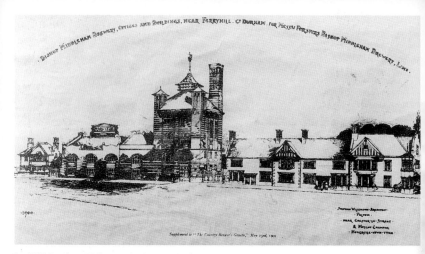

In 1900 Stephen Wilkinson, architect of Pelton near Chester-le-Street, was commissioned by the Forster brothers to submit plans for a new Brewery at Bishop Middleham. This drawing appeared in *The Country Brewers Gazette* for 23 May 1901.

A group of lads at Forster's Brewery, c. 1914. When men were required to serve in the First World War many of their jobs were filled by these young men. Consequently young girls and women were offered this type of work.

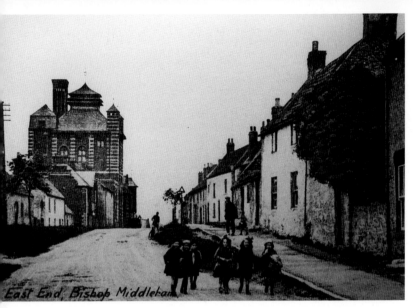

East End, Bishop Middleham

The Brewery and High Street, c. 1924. Having the appearance of an oriental temple with its pagoda type roof projecting from its pinnacle, this Brewery was erected in 1900. With the emergence of larger companies and greater competition, Forsters decided to sell out to Newcastle Breweries. Consequently brewing ceased at Bishop Middleham in 1913. Becoming a bottling and storage house, a large number of young girls were employed. Many travelled from nearby Cornforth and the sound made by their clogs echoed around the village. For a short while, during the mid 1930s, a Government Sponsored Adult School was set up, where unemployed men were taught simple tinsmith and joinery skills. Abandoned towards the late 1930s, the Brewery became a Prisoner of War Camp for German and Italian prisoners. As the war in Europe drew to its final conclusion, the prisoners enjoyed a fair amount of freedom. The Italian prisoners are still remembered for searching the old walls down Well Lane for snails, which they considered a great delicacy. Sent to work on nearby farms, each prisoner had a large yellow piece of cloth in the shape of a circle or diamond sewn to his jacket and trouser leg. In 1959 approximately twenty men were employed on the Brewery wagons when it was used as a distribution centre. Considered surplus to requirements, it stood empty for a short while until it was finally demolished in 1964.

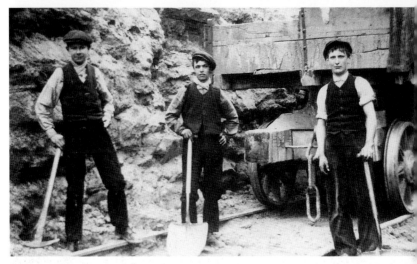

Bishop Middleham Quarry, c. 1912. William Duffield, left, and his two workmates break off from wagon-loading at the quarry face to have their photographs taken beside this early eight ton dumb-buffered wagon. Made from sturdy wood baulks, this type of buffer formed part of the carriage structure of the wagon. When new standards were introduced in 1888 their use on main line track was prohibited.

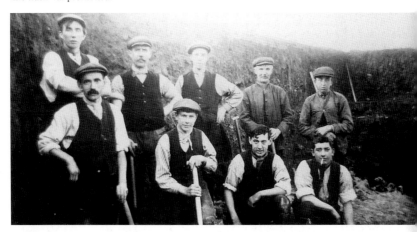

A group of men employed at the quarry face, c. 1912. The men include: H. Laverick, W. Duffield, T. Curbison and back row, left, Mr Maddison who kept the newsagent shop in Front Street during the 1950 and '60s. Built to sell drapery in the early 1930s, the shop now provides general goods and is run by Joanne Sheehan.

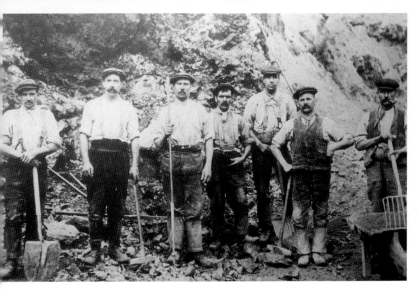

An unknown group of men at the quarry face, *c.* 1890. The man third from the left is holding a steel rod which was hammered into the rock to make a hole which was then packed with explosives for blasting the rock.

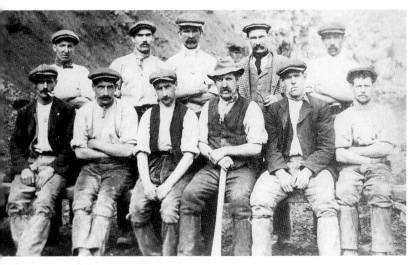

Quarrymen, *c.* 1912.

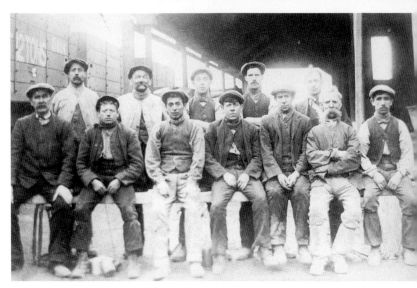

Quarrymen outside one of the sheds in Stoney Beck Quarry, Bishop Middleham c. 1913. Mr H. Smith is seated second from the right.

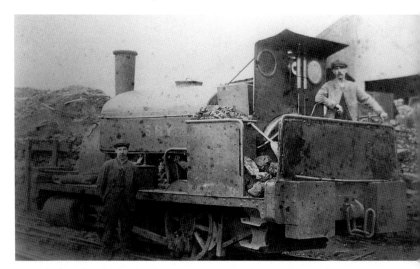

Stripped of its cabin, this 'Tankie' locomotive was used to shunt trucks to and from the various quarry faces at Bishop Middleham Quarry, c. 1920.

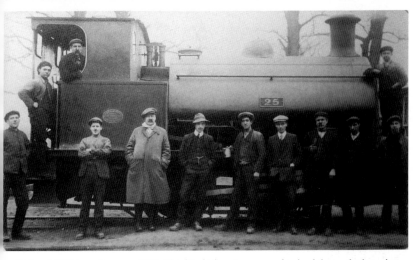

Bishop Middleham Quarry, c. 1920. This 'Tankie' engine was used to haul the trucks from the quarry sidings to the junction of the main mineral line which was situated just to the east and below Stony Hall farmhouse. This line led to Port Clarence, Teeside. The men are, left to right, standing on the engine: -?-, J. Smith (driver), W. Duffield. Below: -?-, R. Barker, Mr J. Barker (manager), A. Smith, H. Walker, J. Reed, C. Duff, J. Denton, -?-.

The rail tracks and wagons leading to the quarry face, of Stoney Beck Lane Quarry, c. 1919. Placed upon the magnesium outcrop that stretches from Tyne to Tees, the village was ideally situated to supply its mineral to the blast furnaces that sprung up at Middlesbrough during the 1850s. As improvements to the furnaces were made, a better grade of stone was demanded. Considered unsuitable for these new requirements, the quarry closed in the mid 1930s.

The old Sedgefield fire station, which stood on the site of the present building, was built around the end of the Second World War. During the war the building was also home to the ambulance service which later moved to its present site in Fishburn. The fire station was very basic (in fact a row of garages), and it was not altered until 1954 when a watch room and recreation room were added.

The present fire station in 1967, the year after it had been built. In 1970 the station was upgraded from a one pump (appliance) to a two pump. Sadly due to financial cutbacks the station was once again reduced to one pump in 1996.

*Right:* One of Sedgefield's major fires took place in the summer of 1996 when the premises of George Bolam, the butcher, on Salters Lane Industrial Estate, were razed to the ground. Appliances from various parts of the county attended the fire. Seen here is the turntable ladder from Darlington attending to buildings to the rear.

*Below:* Originally built in 1966 the present building was never officially opened. This, however, was rectified on 25 February 1994 when County Councillor Ken Manton performed the opening ceremony. Station Officer, Ken Saddler, left, and Councillor Ken Manton are with four pupils of Hardwick Primary School who were prize winners in a competition to celebrate the event. Each of the four winners was presented with a child size firefighters cap complete with insignia.

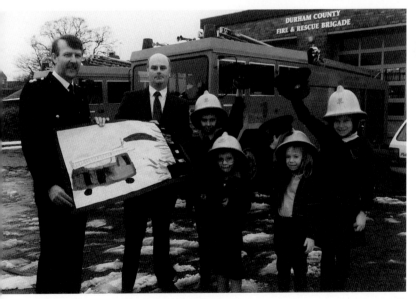

Mr and Mrs William Hodgson, c. 1912. William was a survivor of the explosion at Bishop Middleham Colliery on Sunday, 2 March 1930. A terrific bang was followed by a pillar of smoke and ash which was seen to spiral several hundred feet into the cold night air accompanied by debris from the mouth of the mine shaft. An explosion of gas had taken place four hundred feet underground, in the vicinity of the shaft bottom area. It is believed that the cause of the explosion was due to a faulty lamp carried by William, the mine deputy, which ignited gas in the return air ventilation system. Three men were injured; Joseph Spence aged twenty-five of Spennymoor, Arthur Coulson aged seventeen, who lived in Bishop Middleham, and William, who suffered extensive burns to his face and body and for many months his eyesight was badly affected. Sadly, Joseph Spence was to die later of his injuries. In 1943, William (Bill), with his wife Harriet and family, became licensee of the Cross Keys. They retired in 1956 to be among the first tenants of the newly built bungalows erected by the council in The Park. His doctors said he was a man in a million to have survived the explosion.

Mr and Mrs Tom Cooke, 1932. On the night of the explosion Tom Cooke was working the night shift at Bishop Middleham Colliery. His duties as the 'Banksman', apart from the responsibility of being in charge of the mine shaft when he signalled for the cages that lowered the men, also included searching for contraband, (cigarettes etc.) which were illegal underground and a contravention of the Coal Mines Act. He also, after receiving each mans identification token, noted their names in a record book. It was while he was preparing these records in the timber constructed 'cabin' situated near to the mine shaft, that he was physically blasted from his seat into the cold night air. The cabin was completely demolished with debris flung far and wide. Miraculously Tom escaped from the terror that struck in the last dying minutes of that Sunday night. Suffering a dislocated shoulder blade, his other injuries included numerous splinters of wood, that were embedded to almost every part of his body. Shaken and badly bruised he had for one brief moment stared death in the face, then lived to tell the tale.

*Six*

# Transport

One of the first motor cars that came into Bishop Middleham was owned by Joseph Barker Ross, the landlord of the Dun Cow in the village. Believed to have been a Vauxhall, Mr Ross proudly stands beside his new car, while his son Joseph is sitting behind the steering wheel, around 1924.

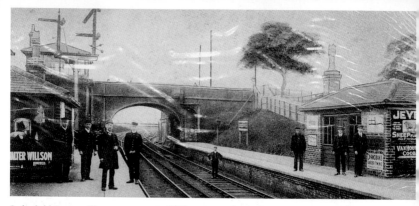

Sedgefield Station. The station master, William Manners, is the imposing gentleman in the foreground. When the line was first laid in the 1830s it was proposed to take in Sedgefield but this was strongly opposed by Squire Ord of Sands Hall and as a result the station was built one and a half miles west of the village towards Bradbury. It was a very busy station both for goods and passengers, seeing the arrivals and departures of many distinguished people, including Royalty, as they made their way either to Hardwick Estate or, more particularly, the Wynyard Estate owned by the Londonderry family. Prior to the First World War passengers were conveyed from the village by horse buses which were owned by the Swinbanks and Mowbrays. By the early 1950s the station had ceased to function except for the occasional freight train. In 1959 Berry Watson and Co. opened a petroleum oil refinery in the station yard. This is still a fuel distribution centre today.

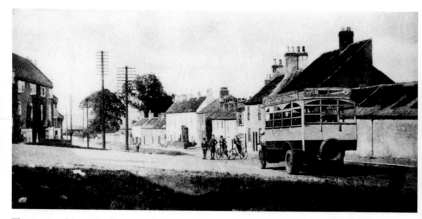

This is one of the earlier lorry type buses, possibly a Ford T, used in Sedgefield. These buses were used by locals to travel to Stockton and Darlington. In the early days of operation these buses had no fixed timetables or fare lists. At this time the bus depot or 'yard' was situated in the west end of the village.

The Cross Keys Inn, Bishop Middleham, *c.* 1890. The landlord, John Ross was also a blacksmith and farrier. He is seen preparing one of the fore hoofs of this fine looking horse, prior to fixing an iron shoe. The blacksmith shop was situated in the yard behind the inn. Notice John's initials on the tool box. The present landlords are Carole and Mervyn Smith.

Before the advent of the Autobus, the wagonette or brake was the common mode of transport. This brake belonged to Mr Davidson and Sons of Coundon. The man standing on the brake steps is Ralph Bellerby Haile who was one of the first tenants of Insula Cottages, Bishop Middleham when they were built in 1921.

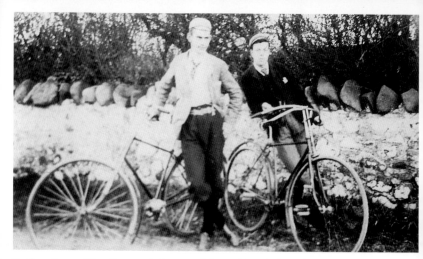

Brothers Tom and Stan Stacey with their push bikes on Mainsforth Bank, *c.* 1914.

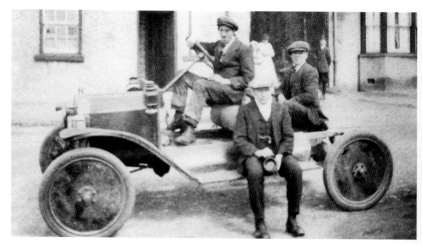

Bank Top, Bishop Middleham, *c.* 1913. The man seated behind the driver of the vehicle is Archibald Ross, while the man sat on the running board holding a lamp is thought to be Jim Siddle. An act of 1865 prohibited vehicles from travelling at more than 4 m.p.h. on a public highway. This act was relaxed in 1896 when the speed limits were increased to 12 m.p.h.

William Duffield was the proud owner of this 1914 Dennis Autobus. George Lee of Church Street, Bishop Middleham began a regular autobus service in 1922 which ran between Ferryhill, Bishop Middleham and Fishburn. At approximately the same time Messrs Coats, Ingle, Thompson and Young formed the City Bus Company and began to supplement the route with a much needed half hourly service. Ultimately William Duffield along with Mr T. Wilkinson took these services over. Later, further re-organisations were to take place when Mr Duffield joined with Favourite No. 2 Service, which operated between Bishop Auckland and Middlesbrough, and Mr Wilkinson's Spennymoor to Stockton Service.

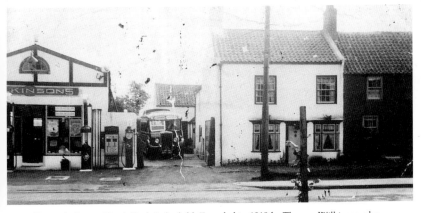

Wilkinson's Garage North End, Sedgefield. Founded in 1919 by Thomas Wilkinson, the company operated under the name of Wilkinson's Motor Services but was known locally as Wilkies. It was purchased by United Automobile Services Ltd on 26 February 1967.

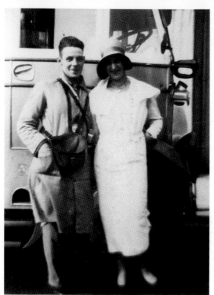

Wilf Johnson and his wife, Irene, beside this Maudslay bus, c. 1937. Notice the hand crank for starting the engine and the horn which was operated by squeezing a rubber bulb. Employed as a driver/conductor by Mr William Duffield, the Bishop Middleham bus proprietor, Wilf was a popular figure on the Spennymoor to Stockton route. When Mr Duffield sold out Wilf found employment as the ambulance driver at Mainsforth Colliery and during his spare time worked as a labourer in the Fitting Shops. Wilf's sons Derek and Neil are presently active as members of Bishop Middleham Parish Council. Apart from providing an excellent service to the community as the village milkman, Neil, with his wife Gillian and friends are instrumental in organising the Village Country Fair which commenced in 1993. It is currently being held in a field close by Island Farm which is presently in the hands of Mr and Mrs Joe Hirst and their son John.

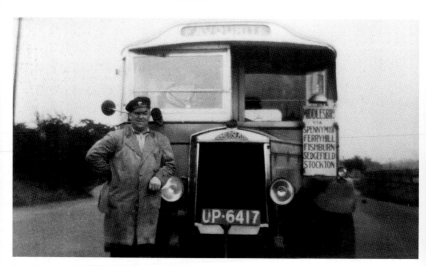

Bus driver Archibald Ross at the top of Quarry Bank (Stoney Beck Lane), Bishop Middleham, c. 1938. He is beside a Maudslay which belonged to William Duffield, proprietor of the Favourite Buses.

Mrs Annie Duffield and her niece Mary Ross in front of this Leyland Bus in High Road, Bishop Middleham, *c.* 1946. On this occasion the bus appears to have been hired for a private function, but as part of the Favourite Service it would normally have been in daily use on the Stockton to Bishop Auckland route. With inspectors employed to see that an accurate service was being provided to the public, it was virtually unknown for a bus to be more than two or three minutes late. After many years as a bus driver himself, Charles 'Charlie' Vasey was promoted to an inspector where he was highly respected and is still remembered as a very popular figure on the route. At a time when two hundred and forty pennies made one pound note, a trip on the bus to the nearest market which was held at Ferryhill cost three pence return. A loaf of bread cost four and a half pence and a seat at one of the three picture houses cost nine pence.

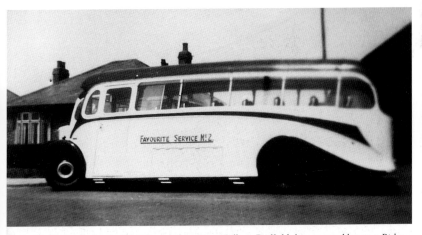

One of the Favourite Service No 2 Buses belonging to William Duffield that operated between Bishop Auckland and Middlesbrough via Bishop Middleham, *c.* 1947. The service was always appreciated by people living in the area and in particular by the men employed at Mainsforth Colliery who, after years of walking to and from their work, were able to enjoy the luxury of being able to ride to and from their employment.

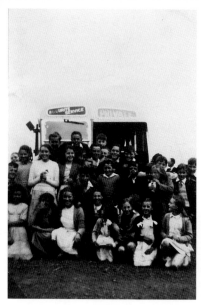

*Left*: William Duffield was hired by the various organisations in the area for their means of transport. This group of smiling youngsters from Bishop Middleham C. of E. School have obviously enjoyed their school trip to Whitley Bay in the summer of 1949. Notice the two children enjoying their bottles of milk. Many will recall giving teacher two and a half pence on a Monday morning. This ensured a bottle of milk for each morning at school.

*Below*: A group of passengers and their driver in front of a Wilkinson's tour bus, outside the Sedgefield depot, *c*. 1940. The company ran a variety of services over the years which included a regular summer service to Blackpool, together with many private hire services.

*Seven*

# Sport and Leisure

Christmas, 1962. Members of Bishop Middleham Wesleyan Chapel sing carols outside 'Greystones' bungalow, home of Mr and Mrs E. Smith. A keen amateur photographer, Mr Smith was also the village postmaster for many years.

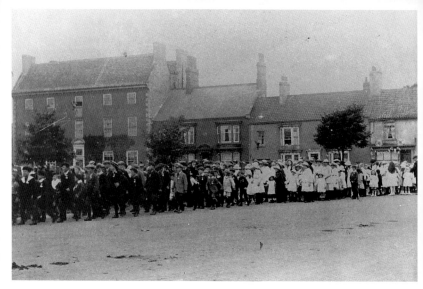

The younger people of Sedgefield dressed in their Sunday best and wearing their commemorative medals march through the village during the celebrations to mark the coronation of King George V and Queen Mary in 1911.

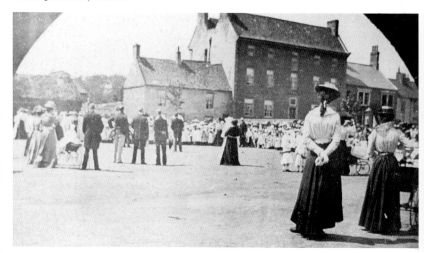

Sedgefield celebrates the coronation of King George and Queen Mary in 1911. The Manor House lies in the background. At this stage the village green did not exist.

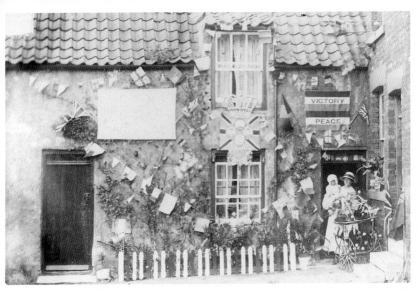

Celebrations in 1919 to commemorate Victory and Peace after the First World War. The cottages in the West End of Sedgefield are decorated for the occasion. For many years one of these cottages sold newspapers.

A group of young girls charmingly posed in the grounds of Sedgefield Rectory in the early part of the twentieth century.

The summer of 1902 was dominated by the celebrations held for King Edward VII's Coronation. The peace of Vereeniging also brought the Boer War to an end which gave cause for a double celebration. In the grounds of Middleham Hall are, sitting in the front row, fourth and fifth from the left, sisters Mary and Elizabeth Duffield. Standing fifth from the left is Mr M. Forster and in the centre is Revd M.B. Parker.

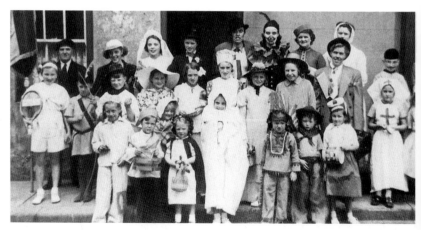

Red Lion Corner in the summer of 1950. Bishop Middleham children assemble in fancy dress outside the first house in Bank Top Street, before proceeding to the 'Field Day' which was held in Foumarts Lane in the field just below Broad Oak Farm. Built in 1925, by General Sir Herbert Conyers Surtees, the farm took its name from Broadoaks, one of the Surtees estates situated near the river Tyne at Ovingham, Northumberland.

St Michael's Church Opera Group was formed in 1954 by Revd J. Porteus, the parish vicar.
After presenting *The Mikado* in 1956 to a packed audience at the old school, a number of highly
successful productions followed. They included *The Pirates of Penzance, The Gondoliers*, and in
1962 the players presented *Iolanthe*. Front row, left to right: S. Sayers, -?-, -?-, J. Fawcett, J. Elsey, -?-,
D. Foster. Middle row: -?-, H. Graham, M. Scott, V. Coates, -?-, A. Hymer. Back row:
B. Hodgson, J. Pickett, V. Cooke, Revd Porteus, J. Watson, A. Catherall, P. Smith, -?-, -?-,
T. Ward, -?-, -?-, J. Scott, T. Watson, A. Courtney.

Bishop Middleham Village Hall was officially opened on the 30 August 1964 by George Metcalfe,
The County Director of Education. The building cost £12,000 to erect. Doreen Labron,
'Miss Bishop Middleham', was present at the opening along with members of various village
organisations. Back row: left to right: J. Cummings, D. Kell, N. Haile, P. Smith,
G. Metcalfe, K. Knaggs, R. Hardy, J. Edgar, G. Clarke, H. Harley, R. Cross. The ladies are, left to
right: A. Richardson, D. Calder, N. McGowan, M. Raine, L. Robson, D. Labron, J. Smith,
F. Riley, N. Ellerton, D. Chatt, D. Turner.

The Inaugural meeting of the Sedgefield Women's Institute outside the Banqueting Hall in the grounds of Hardwick Hall in 1918. Lady Boyne is seated on the plaid rug, to the right of the dog. Notice the old fashioned bath-chair. Sedgefield W.I. has thrived right up to the present day and will celebrate its 80th anniversary in 1998.

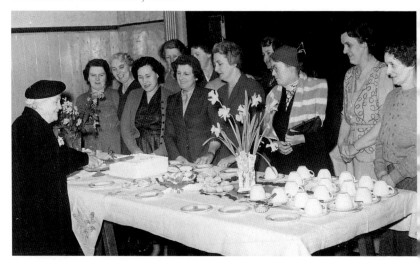

The 35th anniversary of the Sedgefield Women's Institute in February 1953. Mrs J.A. Noakes cuts the cake while the members of the Committee look on.

Bishop Middleham Women's Institute, c. 1951. Since its formation in the February of 1928, its members have been involved in almost every organisation and event held in the village, especially during the Second World War. While husbands, sons and brothers were away fighting, they were active on the Home Front helping the war effort with food parcels, knitting and collecting almost everything recyclable. Included are mesdames, G. Haile, V. Tinkler, R. Sherwood, P. Smith, A. Smith, J. Wilkinson, F. Riley, A. Haile, B. Coates, M. Curbeson, J. Clark, R. Walker, N. Ellerton, A. Errington, M. Lee, and Mrs Harrison, choir mistress.

The Golden Jubilee celebrations of the Wesleyan Chapel at Bishop Middleham in September 1963. Left to right are: Revd W. Tate, Revd J. Porteus, Vicar of St Michael's, Revd Bramhall, Revd Edwards, the Circuit Superintendent Minister and William Healey, the Soloist.

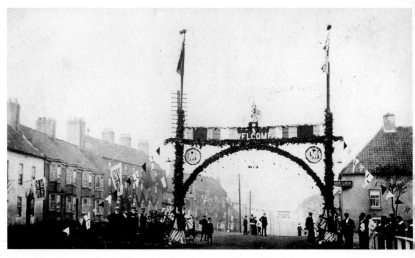

The celebrations in Church View, Sedgefield for the wedding of Lord Boyne to Lady Margaret Lascelles of Harewood house in Yorkshire in October 1906. The couple made their home in Hardwick Hall.

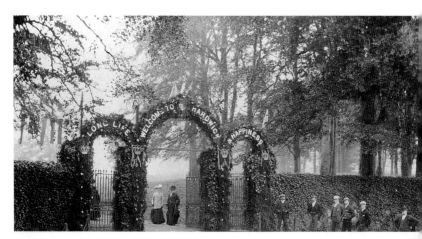

The entrance to the drive leading to Hardwick Hall decorated for Lord and Lady Boyne's wedding. This spot lies between the present West Park Lane and Hardwick Road. Part of the wall is still standing and despite the disappearance of this imposing entrance the bus stop there is still known locally as 'The Park Gates'.

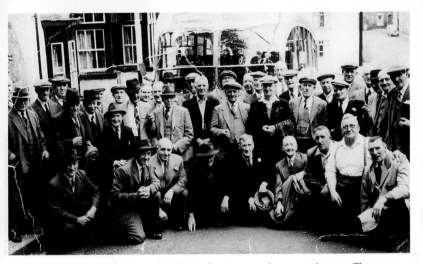

The Sedgefield Social Club opened in 1946 and ran an annual outing to the coast. This photograph is believed to date between 1946 and 1950, and many notable local businessmen and farmers feature on it. On the far right is the bus driver, Steve Brain. The bus belonged to Wilkinson's. They are leaving from outside the Social Club in Rectory Row.

SEDGEFIELD SOCIAL CLUB TRIP, RECTORY ROW.     ( Post 1946 - Club opened that year )

BUS  WINDOWS

1.     ?    Craggs
2.   Billy  Musgrave.
3.   Harry   Gent.
4.   ?    Smith.
5.        Webb ?.
6.   Billy Hutton.
7.   Arthur Hodgson.
8.   Alf Smith.
9.   Jack (Nat) Iceton.
10.  Harold Davison.

11.   ?   Curbyson.
12.     ?
13.  Tom   Wilkinson.
14.       ?
15.  Usher Stubbs.
16.  Herbert Merrington.
17.  Jim Roper.
18.       ?
19.  George Jordison.
20.  Bill Trowell.

21.  Ernie Atkinson.
22.   ?  Walker.
23.  Johnny Iceton.
24.  Bob Henderson.
25.  Jack Hindmarsh.
26.  Charlie Moore.
27.  Charlie Walker.
28.  Ralph Macdonald.
29.  Billy Booth.
30.  Ben Ranson.

31.    Joe Iceton
32.    Eddie Threfall
33.    Joe Grundy.
34.      ?
35.      ?
36.   Leslie Fletcher.
37.   Jack Nesbitt.
38.   Bill Blackwood.
39.   Steve Brain.

The South Durham Hunt. Ralf Lambton, uncle of the first Earl of Durham, moved his kennels to Sedgefield in 1804. Sedgefield country is well known in hunting circles and was once known as the 'Melton of the North'. Ralph Lambton was a popular Master whose career came to an end with a bad fall in 1838.

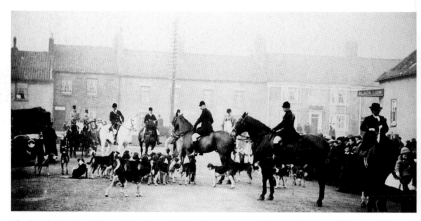

The South Durham Hunt, whose kennels lie a short way out of Sedgefield, assembling outside the Black Lion pub in 1912.

Sedgefield is well known for its Ball Game, held on Shrove Tuesday, and over seven hundred years old. Originally played between the farmers and the tradesmen, the game involves the passing of a small leather ball three times through the Bullring and then, when it is thrown in the air, a hectic few hours begins as the ball is kicked and thrown around the village. The eventual aim is to score a goal in one of two places at either end of the village, a process which often takes several hours. The popularity of the game is revealed by the large number of people gathered on the ground. Another form of entertainment for which Sedgefield is renowned is horse racing with the only racecourse in County Durham being situated just to the south of the town.

The Ball Game in Sedgefield in the 1920s was strictly a male preserve. The game was blatantly so rough that it was necessary to board up the local shops which can be seen in the photograph. The game continues to this day but is now played by everyone including players from the neighbouring villages. Unfortunately the game sometimes comes to a swift halt when some local wag bags the ball and carries it away in his car.

Even as far back as 1911 the annual Shrove Tuesday game of football attracted vast groups to Sedgefield. Unlike the mother with her pram in the foreground, mums today keep small children well clear of the fray.

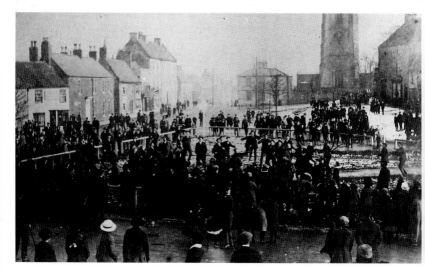

The crowed gather on the village green to participate in the Shrove Tuesday Ball Game, c. 1911.

Mrs Agnes Ward, St Edmund's church verger, at the annual Shrove Tuesday Ball Game in the 1940s. She apparently used to go round collecting funds to buy the ball.

Sedgefield United A.F.C. 1919-20

In 1919 Sedgefield boasted its own United Football Team. Here they proudly pose with a group of supporters in the season 1919-20.

Bishop Middleham AFC, 1919-20. That season they finished runners-up in the Ferryhill and District Second Division.

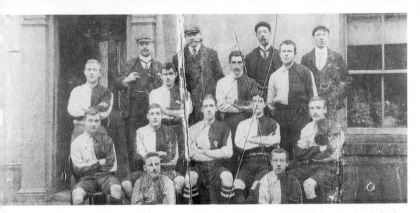

Bishop Middleham AFC, 1903-04. The players and officials, outside the Fleece Hotel, are, back row: T.F. Smith (Committee Treasurer), C. Legge, G. Clarke, J. McCormick. Standing: R. Agar, H. Bulman, J. Murray, J. Wilkinson. Seated: W. Robinson, C. Ross, P. Waistell, C. Walker, F. Haile. Front: J. Lockey (Vice Captain), J. Kelly (Captain). John Ross was the landlord of the Fleece. The present licensee are Mary and Ken Marley. In its early history the village football teams have used several plots of land as their home ground. One early venue was Chestnuts Field, a strip of land where the present allotments are located. Matches were also played on Bradlaws Field which was situated along Highlands Farm Lane. One of the fields along Foumarts Lane, just below Broadoak Farm, was also used.

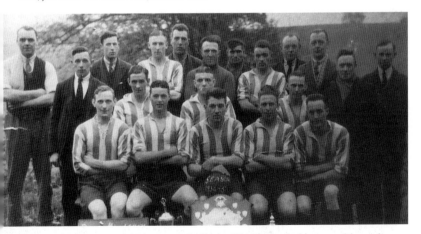

Bishop Middleham United AFC, team and officials, 1934-35. This highly successful team line up for their photographs with an impressive looking clutch of trophies. Standing, left to right: M. Nicholson (Trainer), P. Nobbs, F. Garnham, S. Ross, W. Preston, L. Maddison, L. Robson, F. Hilton, G. Hufford, S. Harper, F. Springhall, B. Hufford. Middle row: P. McGowan, W. Hall, A. Smith. Front row: F. Smith, G. Smith, A. Alison, S. Golding, M. Frisby.

# Acknowledgements

## Sedgefield

Sedgefield Local History Society wish to acknowledge the contribution made by the photographic collections of Mrs Fletcher, Dr Jones, Mr and Mrs D. Threlfall, *The Evening Gazette* and *The Northern Echo*. We are indebted to Durham Fire and Rescue Brigade for their assistance and allowing the publication of brigade photographs. We are also indebted to many people who, over a considerable number of years, have donated photographs to the Society. Every effort has been made to be accurate but there are gaps in our knowledge and the Society would welcome any further information from readers. We thank the Sedgefield Community Association for their support.

Editorial Committee: Joan Smith, Carol Briggs, Colin Richmond, Alison King, Yvonne Dow, Alison Hodgson, Helen Clifford-Brown, Sheila Sutherland and Ian Sutherland.

## Bishop Middleham and Mainsforth

While every effort has been made to contact and acknowledge the due copyright within this book, I wish to thank and acknowledge the people of both Mainsforth and Bishop Middleham who have given permission for the use of their photographs and without whose help and co-operation this publication would not have been possible. I also thank and acknowledge the following: Sedgefield Borough Council, The Archivist, Durham County Hall and The Editor of *The Northern Echo*. I must give special thanks to the following people for giving me access to their private collection of photographs. Mainsforth: Mrs G. Courtney, Mrs A. Smith, Mrs H.M. Stacey, Mrs Z. Whent. Bishop Middleham: Mr and Mrs J. Burn, Mr D. Johnson, Mrs D. Calder, Mr N. Johnson, Mrs B. Coates, Mr and Mrs T. Laverick, Mrs V. Cooke and Violet, Mr and Mrs C. Marshall, Mr M. Davison, Mrs D. Sirrell, Mr and Mrs K. Dove, Mr and Mrs P. Smith, Mrs G. Haile, Mr J. Smith (Fishburn), Mr and Mrs G. Houldsworth (Derby), Mrs I. Vasey, Mr and Mrs K.G. Walker (Sedgefield). And finally for typing my notes, my gratitude and special thanks to Mrs Joyce Morland (nee Watson) who learnt her three Rs in the old school by the edge of the village green.
Frank David Bellwood

*If Thou Be Fond Of Learning Thou Shall Be Full Of Learning In Return*
From a Greek inscription carved upon the door lintel of Bishop Middleham Church Of England School in 1770.

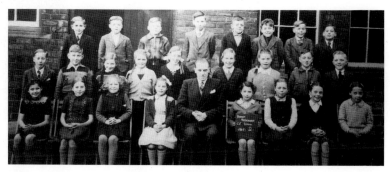

Bishop Middleham C. of E. School, Class 2, 1949.